IMAGES of Rail

BESSEMER AND LAKE ERIE RAILROAD

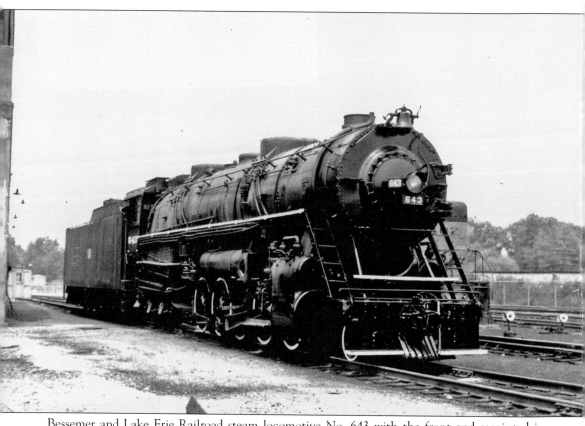

Bessemer and Lake Erie Railroad steam locomotive No. 643 with the front end repainted is posing outside the Greenville roundhouse for photographs for a safety promotion program in July 1968. Baldwin Locomotive Works built this Texas-type locomotive with a 2-10-4 wheel arrangement in February 1944. It was retired during 1953 but was not scrapped. (Greenville Railroad Park collection.)

On the cover: Bessemer and Lake Erie Railroad diesel locomotive No. 703, one of four units each rated 1,500 horsepower, is heading a train of hopper cars south over the Allegheny River. This locomotive was one of 14 type F-7 diesel units built by the Electro-Motive Division of General Motors Corporation at La Grange, Illinois, and placed in service on June 12, 1950. (Ernest W. Casbohm collection.)

IMAGES
of Rail

BESSEMER AND LAKE ERIE RAILROAD

Kenneth C. Springirth

Copyright © 2009 by Kenneth C. Springirth
ISBN 978-0-7385-6266-7

Published by Arcadia Publishing
Charleston, South Carolina

Printed in the United States of America

Library of Congress Catalog Card Number: 2008932787

For all general information contact Arcadia Publishing at:
Telephone 843-853-2070
Fax 843-853-0044
E-mail sales@arcadiapublishing.com
For customer service and orders:
Toll-Free 1-888-313-2665

Visit us on the Internet at www.arcadiapublishing.com

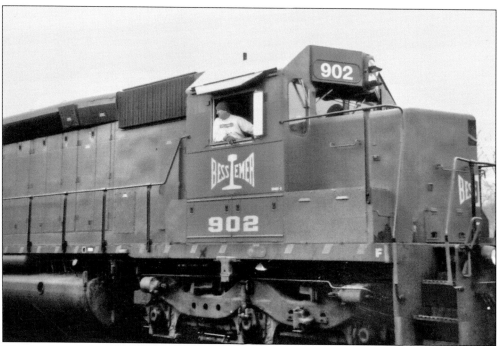

This book is dedicated to past and present Bessemer and Lake Erie Railroad employees like engineer Alan Heckman in locomotive No. 902 at Shenango during 2006. These employees, with long years of service, have contributed to the growth of the railroad and worked together like a family to get the job done. (Photograph by Brian C. Sherman.)

Contents

Acknowledgments 6

Introduction 7

1. Railroad History 11

2. Passenger and Excursion Service 37

3. Maintaining the Railroad 61

4. Steam to Diesel Locomotive Operation 89

Acknowledgments

Thanks to my parents, Clarence and Sallie Springirth, and brother Clarence Springirth Jr. for the time they spent with me and the knowledge they shared along the way. My father was a trolley car motorman in Philadelphia. Brian C. Sherman provided information and photographs. Ernest W. Casbohm made available photographs, schedules, and back issues of the *Bessemer Bulletin*. Thanks to Scott Woods, president of the Greenville Railroad Park and Museum, who obtained permission from the museum to allow the use of photographs and allowed viewing of the *Bessemer Bulletins* it had on file. The Greenville Railroad Park and Museum (314 Main Street, Greenville, PA 16125) has an outstanding collection of information and pictures on the Bessemer and Lake Erie Railroad. Douglas R. Murphy, who years ago began collecting photographs on the Bessemer and Lake Erie Railroad and donated them to the Greenville Railroad Park and Museum, also provided information. Pat Pochatko, who handles the history room at the Albion Area Public Library, made copies of pictures the library had on file. *History of Erie County, Pennsylvania*, volume I, by John Elmer Reed and *Nelson's Biographical Dictionary and Historical Reference Book of Erie County, Pennsylvania* by S. B. Nelson were important reference books. Issues of newspapers including the *Erie Dispatch*, *Erie Weekly Gazette*, and *Erie Morning Dispatch* were reviewed on microfilm at the heritage room of the Blasco Library in Erie. Jim Garts provided contact information. Oliver J. Ogden of the Museum of Bus Transportation located vintage transportation schedules. Raymond E. Grabowski, president of the Lake Shore Railway Historical Society, provided information on past rail excursions. Our thanks to the past and present employees of the Bessemer and Lake Erie Railroad who made this a great system.

Introduction

The Bessemer and Lake Erie Railroad is a north–south railroad in western Pennsylvania from North Bessemer, milepost 0, in Penn Hills Township (near Pittsburgh) north to the borough of Albion, milepost 124, where one line heads nine miles to Wallace Junction with trackage rights via the Norfolk Southern Railway to Erie, Pennsylvania, and the other line goes 14 miles to Conneaut, Ohio. Mileposts are referenced from North Bessemer. At Branchton, milepost 53, a small portion of the branch line that once went east to Hilliards is left. The Bessemer and Lake Erie Railroad was the last railroad to reach Erie County and avoided the Erie railroad gauge confrontation of 1853.

On April 12, 1842, the Erie and North East Railroad was chartered to build from Erie to the New York state line and had an agreement with the Dunkirk and State Line Railroad to adopt a six-foot track gauge, with the first train arriving in Erie on January 10, 1852. West from Erie to Ohio, the track gauge was four feet, eight and a half inches, which required reloading of cars at Erie. The first train operated from Erie to Ashtabula, Ohio, on November 23, 1852. On November 17, 1853, agreement was reached to adopt a track gauge of 4 feet 10 inches from Erie to Buffalo, and work on the gauge change began on December 7, 1853. Erie people resented the plan, because the business of transferring freight from one train to another would be lost. A crowd of Erie residents, led by Erie mayor Alfred King, supported by 150 special police constables cut the railroad bridge on State Street in Erie in half. At Harborcreek Township, farmers tore up track. Passengers and freight were transferred between Harborcreek and Erie by stagecoach and wagon. A uniform gauge of four feet, eight and a half inches was adopted, and feelings eventually healed. The Erie and North East Railroad contributed $400,000 to construct the Erie and Pittsburgh Railroad. The Cleveland, Painesville and Ashtabula Railroad provided $500,000 for the construction of a railroad from Erie to Sunbury, which became the Philadelphia and Erie Railroad with the first passenger train from Philadelphia to Erie on October 17, 1864. Regular passenger service on the New York, Chicago and St. Louis Railroad (Nickel Plate Road) began through Erie on October 23, 1882. The Atlantic and Great Western Railroad completed its line from Salamanca, New York, to Corry, Pennsylvania, in June 1861 and in 1862 was extended westward through southern Erie County.

About 80 miles south of Erie, the Bessemer and Lake Erie Railroad started as the Bear Creek Railroad. The name was changed to the Shenango and Allegheny Railroad, which completed a 20.5-mile line from the village of Shenango to the coal mine at Pardoe (east of the borough of Mercer) during October 1869. By 1876, the railroad was extended southeasterly to Hilliards. The Connoquenessing Valley Railroad, organized on May 3, 1881, built a line from the Hilliards branch to Butler, but financial problems resulted in it merging with the Shenango and Allegheny Railroad. During 1882, the line was extended northward to Greenville. The railroad went into receivership and on January 12, 1888, became the Pittsburgh, Shenango and Lake Erie Railroad.

After the Erie Extension Canal from Greenville to Girard was abandoned in 1871, plans were formulated to build a railroad on the canal's towpath by the Erie, Shenango and Pittsburgh Railway, which merged into the Pittsburgh, Shenango and Lake Erie Railroad. Train service reached the village of Osgood on December 17, 1888, and the borough of Albion on June 8, 1891, and the line was completed to Conneaut on August 15, 1892. At Conneaut, the Conneaut Terminal Railroad was formed on November 18, 1892. Construction of tracks and other rail facilities began in 1893 by the Conneaut Construction Company, and the property was leased to the Pittsburgh, Shenango and Lake Erie Railroad. On July 1, 1891, the Pittsburgh, Shenango and Lake Erie Railroad leased the Meadville, Conneaut Lake and Linesville Railroad, which operated between the city of Meadville and borough of Linesville. This became the Meadville branch and served Exposition Park via a one-mile spur track, which was built from Lynces Junction to the Exposition Park grounds in 1891. Obtaining trackage rights from the Nickel Plate Road from Wallace Junction to Cascade Street in Erie, the line was completed to Twelfth Street near Peach Street in Erie on May 29, 1893. The Butler and Pittsburgh Railroad, organized to build a line from the city of Butler south to the Union Railroad at the borough of East Pittsburgh, merged with the Pittsburgh, Shenango and Lake Erie Railroad on January 18, 1897, creating the Pittsburg (without the *h*), Bessemer and Lake Erie Railroad. The line from Butler to North Bessemer was completed on October 26, 1897, which included a 3,438-foot-long bridge across the Allegheny River. Carnegie Steel Company, headed by Andrew Carnegie, had the iron ore and the vessels to transport the iron ore and gained control of the railroad, which on December 31, 1900, became incorporated as the Bessemer and Lake Erie Railroad to transport the iron ore from Lake Erie to the company's Pittsburgh steel mills. The railroad became a subsidiary of United States Steel Corporation, which took over Carnegie Steel Company in 1901.

Typical freight cars of the railroad from 1869 to 1895 had a capacity of 15 to 30 tons. By 1899, all steel hopper and gondola cars with a 50-ton capacity were standard. In 1936, the railroad acquired 77-ton and 100-ton hopper cars.

The Shenango and Allegheny Railroad began passenger service on November 3, 1869. Passenger ridership peaked on the Bessemer and Lake Erie Railroad in 1913. Beginning in 1920, ridership declined except for an increase in 1936 due to workers in the Works Progress Administration traveling to work sites and during World War II. The last regularly scheduled Bessemer and Lake Erie Railroad passenger train operated from Erie to Greenville on March 5, 1955.

On June 3, 1955, a 1.79-mile spur line went into service from the north end of dock No. 4 at Conneaut to an ore storage area known as Perry Bluff. Harrison Construction Company of Pittsburgh graded the roadbed and Bessemer and Lake Erie Railroad employees did the track work.

The borough of Greenville, 72 miles north of Pittsburgh, was the location of the Bessemer and Lake Erie Railroad shops and offices. In appreciation of the role the railroad played in the community, a special testimonial dinner was held at the Thiel College gymnasium on July 18, 1940. A special train brought railroad officers and invited guests to Greenville. The *Bessemer Bulletin* of October 1940 reports that at the dinner Frank L. Fay, president of the Greenville Chamber of Commerce, stated, "We are here to honor Greenville's No. 1 industry, without which there would be no Greenville as we now know it. It has furnished many citizens who have taken active parts in every phase of community life and has been a strong supporter of everything that is good in the community."

The *Bessemer Bulletin* of November 1950 notes, "We have the largest fleet of 90 ton hoppers of any railroad in the world. Our standard rail weighs 155 pounds per yard—the heaviest rail used in this country today. More tonnage passes over each mile of the Bessemer in one day than any other class I railroad in the United States." As freight car capacity increased over the years, the railroad improved track maintenance by using treated ties, high-quality heavier rail, and better track ballast (crushed rock placed between and below the railroad ties).

Centralized Traffic Control (CTC), manufactured by Union Switch and Signal Division of Westinghouse Air Brake Company, went into operation on June 14, 1956, controlling 135 miles

of track between XB tower, located at North Bessemer, to RX tower, located in Albion, and resulted in the removal of 85 miles of second track. The *Bessemer Bulletin* of September 1956 notes, "The movements of trains throughout the C.T.C. territory are indicated by small red lights on the control panel. A graphic record is made at each controlled point (a total of 27) as to the time each train arrives and departs, and also as to the time each power switch and each home signal is positioned for a train movement." CTC was located in Greenville until 1990, when it was replaced by a computerized system used with the Union Railroad.

In 1936, the Bessemer and Lake Erie Railroad acquired its first diesel switcher, No. 281, for yard duties, but the second diesel switcher, No. 282, was not purchased until 1949. On June 12, 1950, the first freight train operated by diesel road units No. 701A, 701B, 702B, and 702A departed Greenville at 6:00 a.m. southbound to North Bessemer. People came out in large numbers to wave to the train. This was part of an order of 14 1,500-horsepower type F-7 diesel units described in the *Bessemer Bulletin* of July 1950: "These locomotives were built by the Electro-Motive Division of General Motors Corporation at LaGrange, Illinois. They are painted orange and black in an attractive design, with the familiar Bessemer emblem in white on the front and sides." The A or lead units are numbered 701A to 707A and the B or booster units 701B to 707B. The article continues, "When four units are operated as one locomotive, they provide a locomotive of 6,000 horsepower, with a total length of 201 feet, 4 inches, and a total weight of 496 tons. This locomotive has a starting tractive effort of 248,000 pounds and a continuous rating of 209,600 pounds at 8.9 miles per hour." The changeover from steam to diesel operation was completed by 1953.

The *Bessemer Bulletin* of March 1952 reports the Bessemer and Lake Erie Railroad opened a new diesel shop at Greenville with units No. 709A and 709B arriving on January 16, 1952, noting,

> At each visit every locomotive coming to Greenville undergoes a schedule of mechanical maintenance. Inspection is made of crankcase, pistons, and cylinder head mechanism, and of engine cooling system operation. Engine air, engine room, air compressor, and electrical cabinet air filters are changed. The journal roller bearings and speedometer drive are lubricated. While the machinists are doing this work, the electricians clean the main and auxiliary generators, alternator, blower motors, and traction motors, and check the brushes and leads. Batteries are checked, traction motor axle and armature bearings and gears are lubricated, and a sequence check of the electrical control system is made. The locomotive is thoroughly cleaned inside and out. The chemists check the lubricating oil to indicate changing time and for indications of potential mechanical trouble, and check the treatment of the cooling water so that the diesel engine and radiators are adequately protected against corrosion.

That maintenance period was about 3,600 miles. On January 21, 1952, a new diesel shop opened at Conneaut for light running repairs plus periodic maintenance and tests. Major diesel engine repairs were done at Greenville.

An Autumn Leaf Special with 900 passengers was conducted by the National Railway Historical Society on October 12, 1958. An Erie Railroad train left Akron and another train from Cleveland merged into one 15-car train at Youngstown, Ohio, which went to Shenango where the Bessemer and Lake Erie Railroad took over for the trip to North Bessemer. The train was returned to the Erie Railroad at Shenango via a photograph stop at Greenville shops. On October 9, 1960, the Buffalo and Rochester chapters of the National Railway Historical Society sponsored a fall foliage excursion from Buffalo, New York, to Greenville. The train of over 600 passengers was operated via the Nickel Plate Road from Buffalo to Wallace Junction where Bessemer and Lake Erie Railroad employees took over.

On July 18, 1992, the Niagara Frontier chapter of the National Railway Historical Society sponsored a trip from Buffalo via the Norfolk Southern Railway to Wallace Junction and Bessemer and Lake Erie Railroad track from Wallace Junction to Girard. The train was turned at Conneaut Junction (north of Cranesville) where the Erie and Conneaut lines meet and used

Bessemer and Lake Erie Railroad tracks to Wallace Junction and Norfolk Southern Railway tracks back to Buffalo. Norfolk and Western Railway class J steam locomotive No. 611 was used for this trip. This locomotive was last used in regular passenger service from Bluefield to Roanoke, Virginia, during October 1959 and was donated to the Virginia Museum of Transportation at Roanoke. Following the merger of the Southern Railway and Norfolk and Western Railway into the Norfolk Southern Railway, the locomotive was restored and began excursion service on August 22, 1982.

With the decline of the steel industry in the United States, tonnage hauled by the Bessemer and Lake Erie Railroad decreased resulting in system cutbacks. Transtar Inc. purchased the railroad on December 28, 1988. *Railway Age* magazine selected the Bessemer and Lake Erie Railroad as the 2000 Regional Railroad of the Year "for its strategic Class I alliances, innovative marketing practices, and strong safety record." On October 21, 2003, the *Pittsburgh Tribune-Review* newspaper reported that the Canadian National Railway Company would acquire the Bessemer and Lake Erie Railroad and the Pittsburgh and Conneaut Dock Company to expand its role in the transportation of bulk commodities for the United States steel industry. On May 10, 2004, the Canadian National Railway Company completed acquisition of the Bessemer and Lake Erie Railroad (a class II railroad carrying primarily coal, iron ore, and limestone) and the Pittsburgh and Conneaut Dock Company (a switching railroad that performs ship-to-rail and rail-to-ship bulk transfer operations for the Bessemer and Lake Erie Railroad at three docks at Conneaut). A class II railroad in the United States is a midsize freight-hauling railroad. In 2006, a railroad with revenues greater than $20.5 million but less than $277.7 million for at least three consecutive years was considered a class II railroad. These limits are adjusted every several years for inflation and other factors.

In 2008, iron ore boats dock at Conneaut, and the iron ore is transferred to hopper cars for delivery by the Bessemer and Lake Erie Railroad to the Union Railroad for steel mills at Pittsburgh. Erie is still reached via trackage rights over the Norfolk Southern Railway (originally New York, Chicago and St. Louis Railroad). Railroad employees work like a family to meet the transportation needs of its customers.

One
Railroad History

The Bessemer and Lake Erie Railroad began as the Bear Creek Railroad, incorporated in Pennsylvania on March 20, 1865. It became the Shenango and Allegheny Railroad on April 9, 1867, with completion of its 20.5-mile line from Shenango to the coal mine at Pardoe during October 1869. Following receivership in 1884, it was taken over by the Pittsburgh, Shenango and Lake Erie Railroad on January 12, 1888. Train service reached Albion on June 8, 1891, and using trackage rights from the Nickel Plate Road reached Erie on May 29, 1893. A merger with the Butler and Pittsburgh Railroad was followed by completion of the line to North Bessemer on October 26, 1897. Carnegie Steel Company obtained control of the line, and it became the Bessemer and Lake Erie Railroad. In 1901, Carnegie Steel Company was taken over by United States Steel Corporation, and the railroad became a subsidiary of United States Steel Corporation. Construction of an 8.81-mile bypass route around Greenville began during 1901 from the village of Kremis to the village of Osgood, which reduced the distance by 3.13 miles and became known as the K-O cutoff. As the volume of traffic increased, trains became longer and heavier, requiring more powerful locomotives. In 1869, locomotive No. 1 with a 4-4-0 wheel arrangement weighed 66,000 pounds. In 1900, locomotive No. 84 with a 2-8-0 wheel arrangement weighed 179,000 pounds. In 1916, locomotive No. 501 with a 2-10-2 wheel arrangement weighed 404,250 pounds. The last steam locomotives, Nos. 643 to 647, built in February 1944 with a 2-10-4 wheel arrangement, weighed 523,600 pounds. On November 26, 1952, Texas-type steam locomotive No. 642 with a 2-10-4 wheel arrangement made its final steam trip to Conneaut. On December 1, 1952, steam switcher engine No. 257 with an 0-8-0 wheel arrangement ended the steam era at the Shenango yard. In 1953, the Linesville branch from village of Shermansville to borough of Linesville was abandoned. The Meadville branch from Meadville Junction to the city of Meadville ended operation on May 13, 1977. In 1983, most of the Albion yard facilities were consolidated at Greenville.

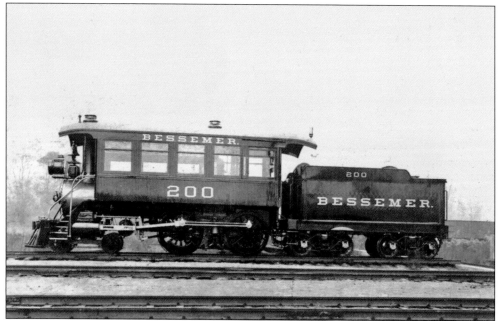

Locomotive No. 200, known as the "Merry Widow," is shown in its later years. It was a conventional locomotive built in 1885 as No. 2 for the Meadville, Conneaut Lake and Linesville Railroad by Baldwin Locomotive Works. In 1891, it became No. 18 on the Pittsburgh, Shenango and Lake Erie Railroad. In 1900, it was modified for inspection purposes as No. 200. (Ernest W. Casbohm collection.)

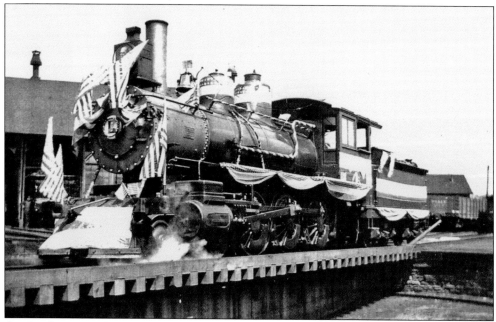

On April 27, 1898, locomotive No. 30 is on the turntable at Greenville. This Ten Wheeler–type locomotive with a 4-6-0 wheel arrangement was built by Pittsburgh Locomotive Works in 1895. Decorated with flags and bunting, the locomotive is ready to haul a troop train for the Spanish-American War of 1898. (Ernest W. Casbohm collection.)

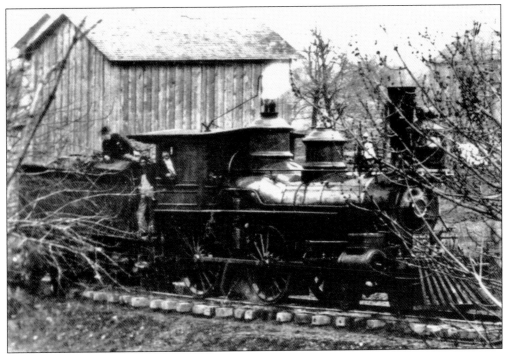

Pittsburgh, Shenango and Lake Erie Railroad steam locomotive No. 2 is the first locomotive to cross State Street in Albion around April 1891. This American-type locomotive with a 4-4-0 wheel arrangement, built in 1869 by Danforth Locomotive and Machine Company of Paterson, New Jersey, weighed 66,000 pounds. (Ernest W. Casbohm collection.)

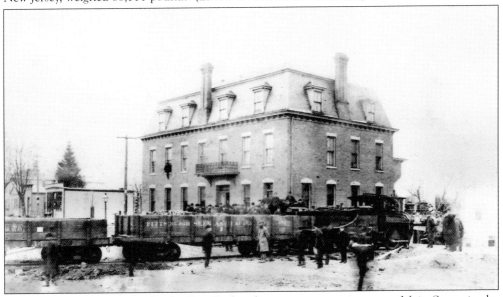

A Pittsburgh, Shenango and Lake Erie Railroad construction train crosses Main Street in the borough of Girard around June 1891. A committee consisting of W. C. Culbertson, R. S. Battles, G. W. Kibler, O. D. Van Camp, and J. C. Murphy raised $23,600 from 36 residents to have the railroad come through Girard. A number of property owners donated right-of-way. (Greenville Railroad Park collection.)

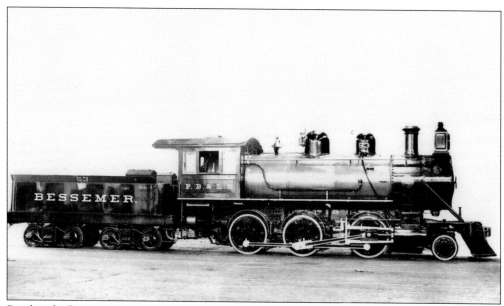

Pittsburgh, Bessemer and Lake Erie Railroad steam locomotive No. 53 is shown as built by Baldwin Locomotive Works in May 1897. This was a Mogul-type locomotive with a 2-6-0 wheel arrangement. It was sold to the Cheswick and Harmar Railroad in western Pennsylvania during 1926. (Greenville Railroad Park collection.)

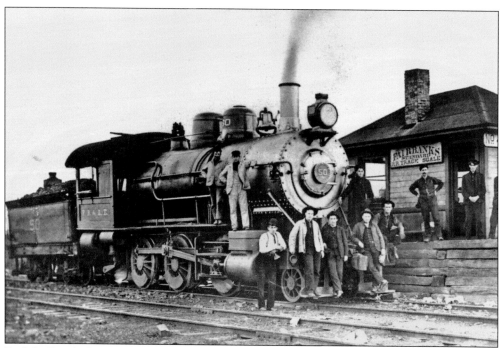

Built by Brooks Locomotive Works during September 1897, Pittsburgh, Bessemer and Lake Erie Railroad locomotive No. 50 is at Conneaut harbor in 1902. This Mogul-type locomotive with a 2-6-0 wheel arrangement had a tractive effort of 28,414 pounds, which is the force that a locomotive can apply to its coupler to pull a train. (Greenville Railroad Park collection.)

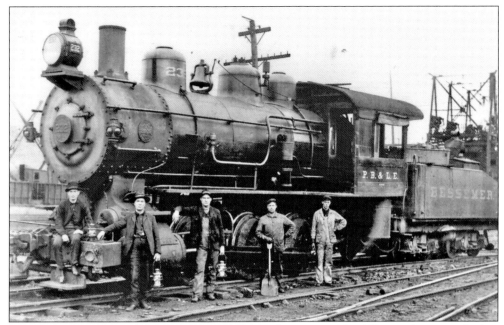

Pittsburgh, Bessemer and Lake Erie Railroad steam locomotive No. 232 is at Conneaut harbor during 1902 with employees, from left to right, J. J. Barrett (switchman), A. Hughes (switchman), J. J. Grace (conductor), F. M. Gee (fireman), and J. W. Marshall (engineer). This class S2B switcher with a 0-6-0 wheel arrangement was built by Brooks Locomotive Works in 1900 and was scrapped during 1936. (Greenville Railroad Park collection.)

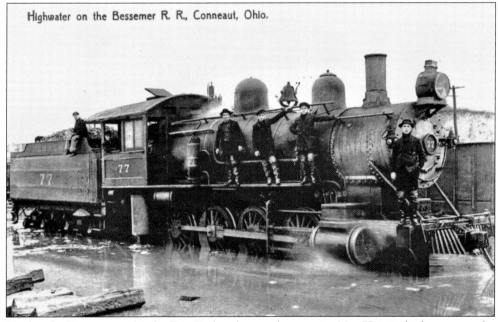

Pittsburgh, Bessemer and Lake Erie Railroad steam locomotive No. 77 is in high water at the Conneaut yard in this postcard postmarked October 11, 1908. This Consolidation-type class C1A locomotive with a 2-8-0 wheel arrangement was built by Pittsburgh Locomotive Works in 1898 and was scrapped in 1927. (Ernest W. Casbohm collection.)

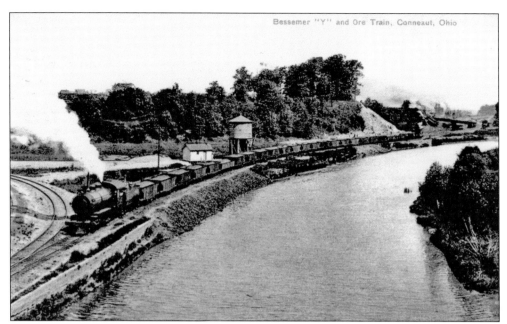

In this postcard postmarked October 29, 1911, a Bessemer and Lake Erie Railroad iron ore train is at the entrance to the rail yard at Conneaut. During the early years, a large amount of iron ore was brought in by whaleback boats that had a rounded deck and rode low in the water according to the *Bessemer Bulletin* of January 1937. (Ernest W. Casbohm collection.)

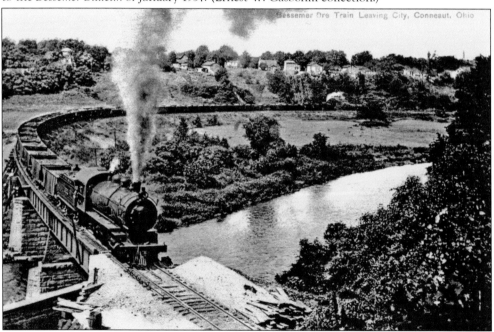

Bessemer and Lake Erie Railroad locomotive No. 153 is hauling an iron ore train southbound leaving Conneaut. This Consolidation-type locomotive with a 2-8-0 wheel arrangement was built by American Locomotive Works at Pittsburgh in September 1902 and was designed to haul heavy trains up the steep grade from Conneaut to Albion at low speed. It was scrapped during 1943. (Ernest W. Casbohm collection.)

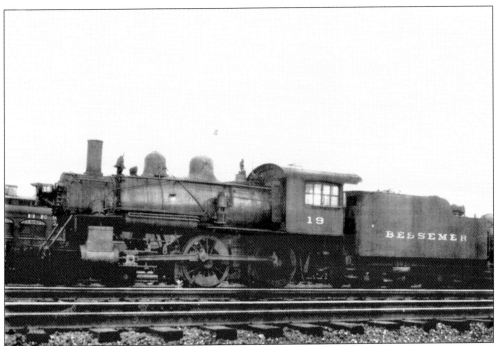

American-type locomotive No. 19 with a 4-4-0 wheel arrangement has seen a lot of use and is awaiting the next assignment on the Bessemer and Lake Erie Railroad. American Locomotive Works at Pittsburgh built this locomotive in March 1908. It was sold to the Union Railroad during 1936. (Ernest W. Casbohm collection.)

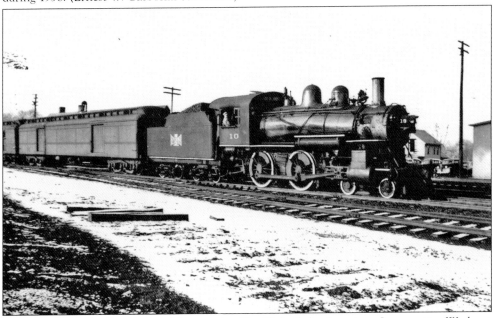

Bessemer and Lake Erie Railroad locomotive No. 10, built by American Locomotive Works at Pittsburgh in May 1919, is at Albion powering a passenger train. This American-type locomotive with a 4-4-0 wheel arrangement had a tractive effort of 24,700 pounds. It was scrapped during 1944. (Ernest W. Casbohm collection.)

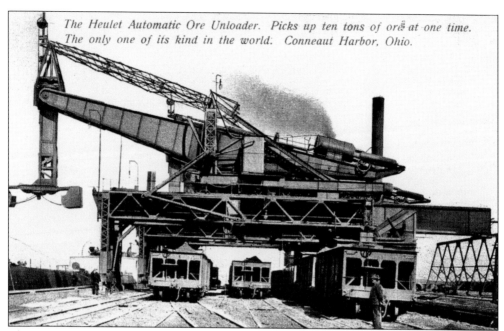

The Hulett automatic iron ore unloader grabs 10 tons of ore at a time from a ship and places it in a hopper car. George H. Hulett (note the misspelling on the postcard above) invented the unloader used in Conneaut beginning 1898. Ships were first unloaded by workers shoveling ore from the ship holds to the deck where it was shoveled into wheelbarrows. Hulett's invention cut unloading of a ship from days to hours. (Ernest W. Casbohm collection.)

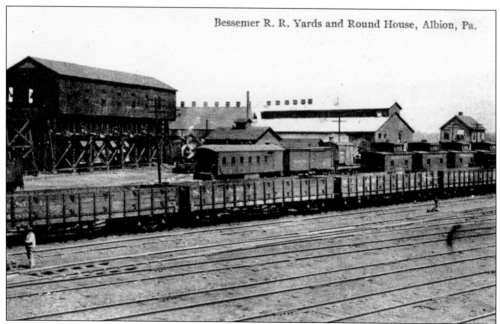

The Bessemer and Lake Erie Railroad yards and roundhouse at Albion are active in this postcard postmarked December 17, 1910. On the left side of the picture, the coal tipple is in place to load coal into the tenders of steam locomotives. (Ernest W. Casbohm collection.)

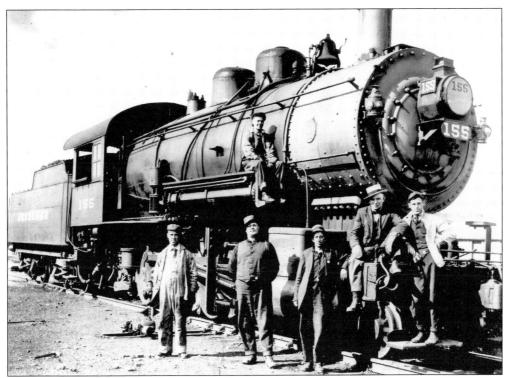

Bessemer and Lake Erie Railroad locomotive No. 155 is at Conneaut harbor in 1915. Built by Baldwin Locomotive Works in April 1909, this Consolidation-type locomotive with a 2-8-0 wheel arrangement weighed 256,880 pounds, had a tractive effort of 63,829 pounds, and was scrapped during 1951. (Greenville Railroad Park collection.)

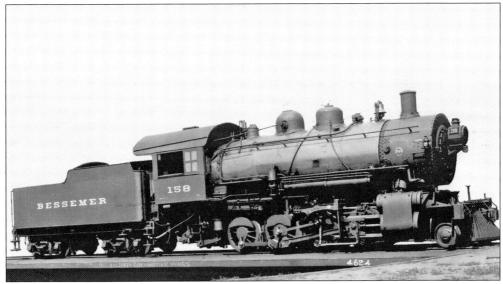

Consolidation-type locomotive No. 158 with a 2-8-0 wheel arrangement is new in this 1913 view. Baldwin Locomotive Works built this locomotive for the Bessemer and Lake Erie Railroad in August 1913. It weighed 268,140 pounds, had a tractive effort of 60,625 pounds, and was scrapped during 1953. (Greenville Railroad Park collection.)

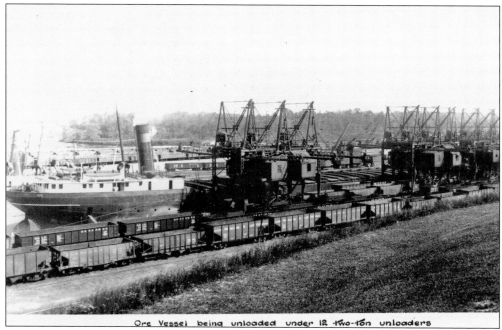

An iron ore vessel is being unloaded under 12 two-ton unloaders at Conneaut harbor around 1910. The first vessel with iron ore docking at Conneaut harbor was the *Charles J. Kershaw* on November 6, 1892. Massive machines were able to efficiently transfer iron ore from a lake boat to railroad hopper cars. (Greenville Railroad Park collection.)

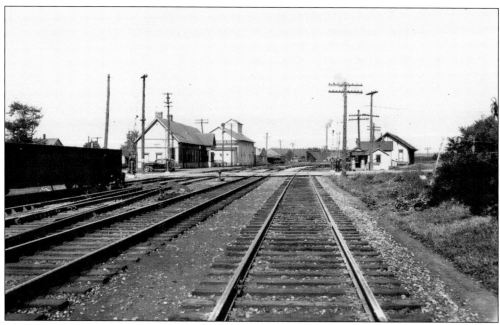

This is the Pearl Street crossing of the Bessemer and Lake Erie Railroad looking north on October 10, 1940. In May 2008, the only surviving building is the Albion feed mill on the west side of the tracks behind the passenger station near Pearl Street in the upper center of the photograph. (Marty Magdich collection.)

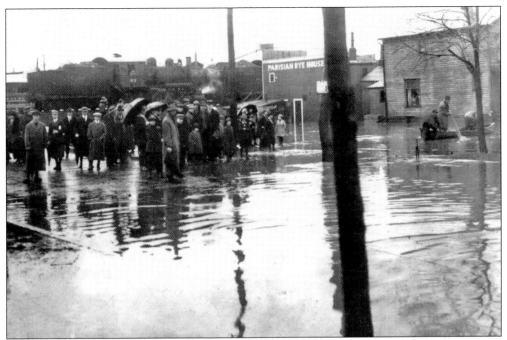

Race and Clinton Streets in Greenville is the scene with an overflow of water on March 25, 1913. In the background, Bessemer and Lake Erie Railroad locomotive No. 91, built by Baldwin Locomotive Works in March 1901, was a Consolidation-type locomotive with a 2-8-0 wheel arrangement. It was scrapped during 1926. (Greenville Railroad Park collection.)

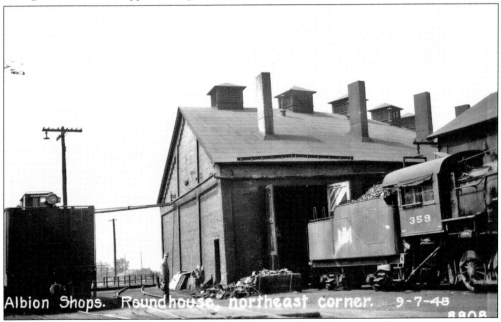

Bessemer and Lake Erie Railroad locomotive No. 359 is at the Albion roundhouse on September 7, 1948. American Locomotive Works at Schenectady, New York, built this Consolidation-type locomotive with a 2-8-0 wheel arrangement in September 1913. It was scrapped during 1954. (Marty Magdich collection.)

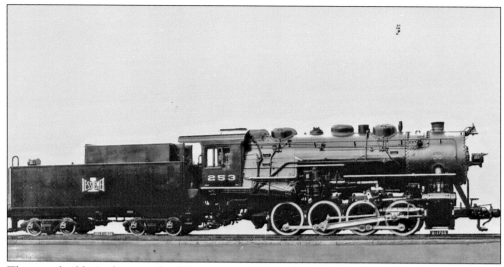

This is a builder's photograph of Bessemer and Lake Erie Railroad switcher-type locomotive No. 253 with a 0-8-0 wheel arrangement. Weighing 279,000 pounds and having a tractive effort of 64,309 pounds, this locomotive was built by American Locomotive Company at Schenectady in July 1936. It was scrapped during 1953. (Ernest W. Casbohm collection.)

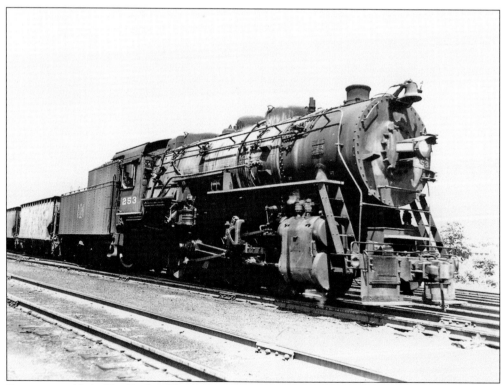

Bessemer and Lake Erie Railroad locomotive No. 253 shows years of service in this yard switching scene. This locomotive was one of 12 switcher-type locomotives numbered 251 to 262 built from 1936 to 1943. These locomotives were scrapped during the time period of 1953 to 1954. (Marty Magdich collection.)

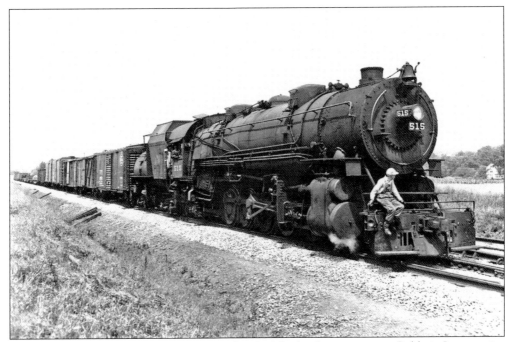

Locomotive No. 515 is a Santa Fe type with a 2-10-2 wheel arrangement. Baldwin Locomotive Works built this locomotive in September 1916 with a tractive effort of 85,680 pounds. The Bessemer and Lake Erie Railroad had 25 of these locomotives numbered 501 to 525. These locomotives were scrapped during the period of 1947 to 1950. (Greenville Railroad Park collection.)

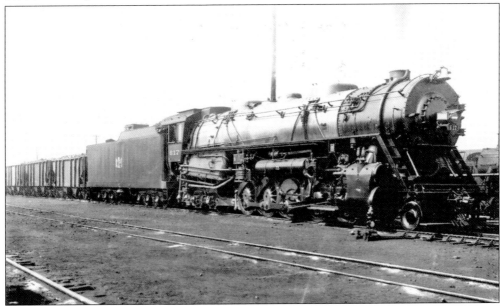

A northbound coal train is at North Bessemer headed by Bessemer and Lake Erie Railroad locomotive No. 617. Baldwin Locomotive Works built this Texas-type locomotive with a 2-10-4 wheel arrangement in June 1936. This locomotive had a tractive effort of 96,700 pounds. It was scrapped during 1952. (Ernest W. Casbohm collection.)

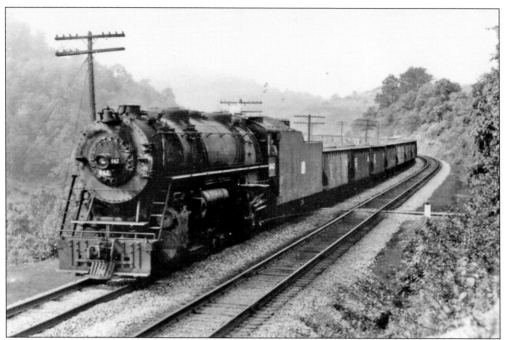

Bessemer and Lake Erie Railroad locomotive No. 642 is near River Valley, a junction point with the former Cheswick and Harmar Railroad, on June 30, 1945. This Texas-type locomotive with a 2-10-4 wheel arrangement was built by Baldwin Locomotive Works in March 1943. From 1929 to 1944, there were 47 of these locomotives built numbered 601 to 647. (Greenville Railroad Park collection.)

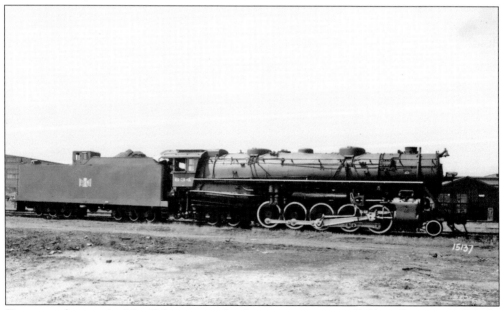

Texas-type locomotive No. 634 is waiting for the next assignment. Baldwin Locomotive Works built this locomotive in 1941. With the exception of No. 643, which was retained, all the Texas-type Bessemer and Lake Erie Railroad locomotives were scrapped or sold during the time period 1951 to 1954. (Greenville Railroad Park collection.)

Bessemer and Lake Erie Railroad locomotive No. 619 is rolling along a well-maintained right-of-way. Baldwin Locomotive Works built this Texas-type locomotive in June 1936. The Texas-type locomotives were fine performers on a railroad that prided itself on efficiency. It was scrapped during 1952. (Ernest W. Casbohm collection.)

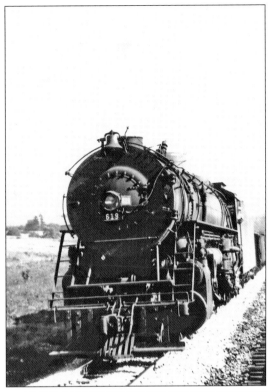

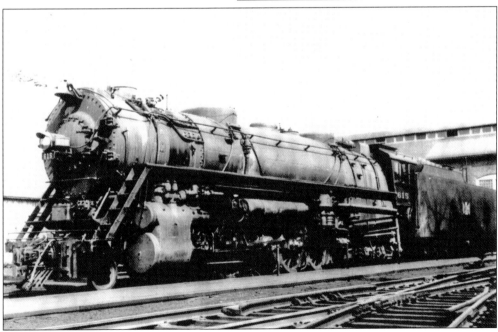

Texas-type locomotive No. 615, built by Baldwin Locomotive Works in June 1936, is waiting for the next crew at the Greenville yard. The 47 Texas-type locomotives were the largest steam locomotives owned by the Bessemer and Lake Erie Railroad. This locomotive was scrapped during 1953. (Ernest W. Casbohm collection.)

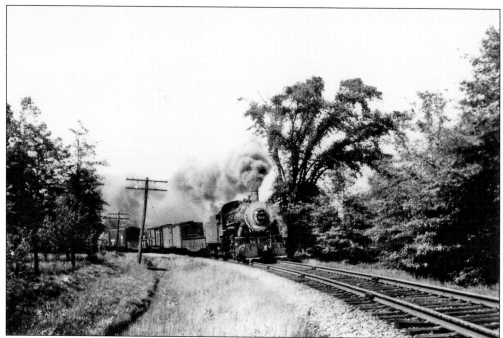

Consolidation-type locomotive No. 350 with a 2-8-0 wheel arrangement is one mile north of Greenville on the old Bessemer and Lake Erie Railroad main line on June 1940. This locomotive was built by American Locomotive Company, Pittsburgh Works, in July 1911 and was scrapped during 1954. (Photograph by Robert G. Lewis.)

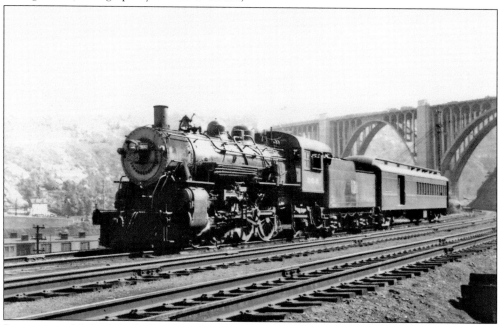

Bessemer and Lake Erie Railroad locomotive No. 902 is at the borough of East Pittsburgh on the Union Railroad on September 17, 1936. This Pacific-type steam locomotive was one of four numbered 901 to 904 built by American Locomotive Company, Schenectady Works, in September 1913, and all were scrapped during 1953. (Photograph by Robert G. Lewis.)

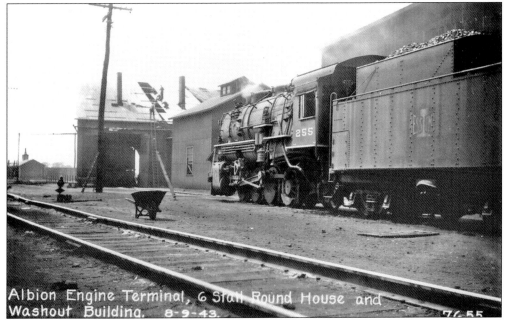

At the Albion engine terminal, class S4B steam locomotive switcher No. 255 with a 0-8-0 wheel arrangement is waiting for the next assignment on August 9, 1943. This locomotive, built by American Locomotive Company in 1937, weighed 279,000 pounds and was scrapped in 1954. The Albion yard had a six-stall roundhouse. (Marty Magdich collection.)

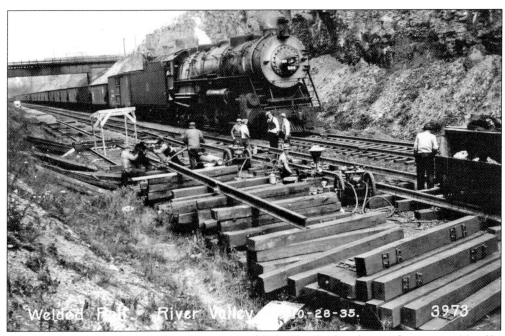

A train of hopper cars headed by Bessemer and Lake Erie Railroad steam locomotive No. 604 is passing by the maintenance crew welding rail at River Valley on October 28, 1935. This class H1B Texas-type locomotive with a 2-10-4 wheel arrangement was built by Baldwin Locomotive Works in 1930 and was scrapped during 1952. (Marty Magdich collection.)

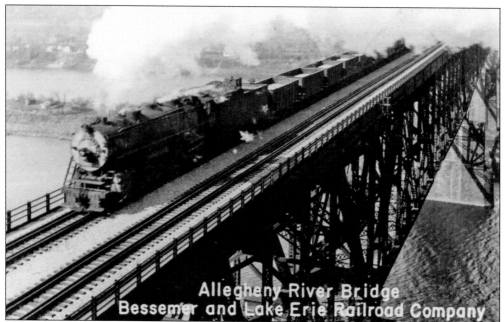

A Texas-type locomotive is crossing the 2,327-foot-long Bessemer and Lake Erie Railroad bridge over the Allegheny River north of Pittsburgh. The original 3,438-foot-long bridge was built by Andrew Carnegie's Keystone Bridge Works during the 1896 to 1897 extension of the line from Butler to North Bessemer. It was replaced by a shorter bridge made possible by filling the south end. (Ernest W. Casbohm collection.)

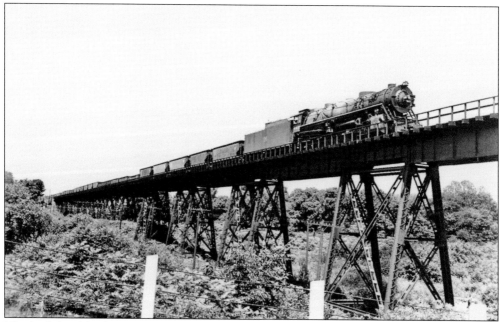

The high-level bridge at the village of Osgood is the scene for this Bessemer and Lake Erie Railroad steam locomotive. This 1,724-foot-long bridge was part of the construction project for the Kremis-to-Osgood line, which was constructed in 1901 and 1902 to reduce the travel distance and grade. The original line was kept. (Ernest W. Casbohm collection.)

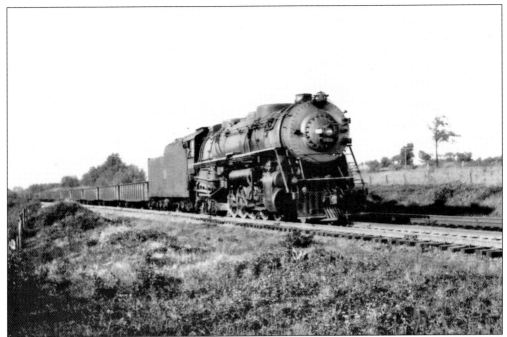

Bessemer and Lake Erie Railroad locomotive No. 620, a Texas-type with a 2-10-4 wheel arrangement, is on the Osgood cutoff, which is east of Greenville, in September 1940. This locomotive was built by Baldwin Locomotive Works in June 1936 and was scrapped during 1953. (Photograph by Robert G. Lewis.)

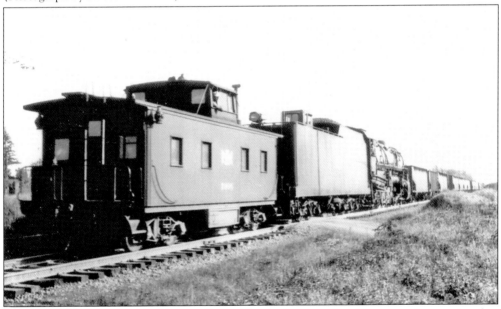

The Williams crossing on the Kremis–Osgood line is the scene for a Texas-type locomotive class H1D powering a Bessemer and Lake Erie Railroad southbound ore train in September 1940. There were 10 of these class H1D steam locomotives, numbered 621 to 630, built by American Locomotive Company, Schenectady Works, in May 1937, and they were all sold to the Duluth, Missabe and Iron Range Railway during 1951. (Photograph by Robert G. Lewis.)

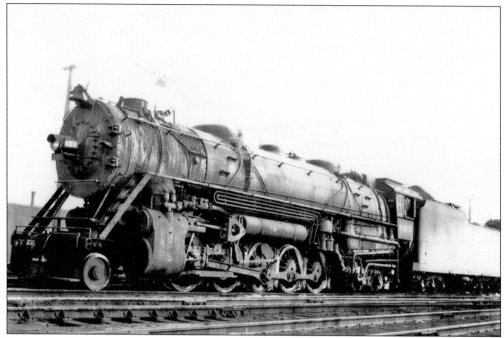

Texas-type locomotive No. 623 is in the yard awaiting the next assignment. American Locomotive Company of Schenectady built this locomotive in May 1937 for the Bessemer and Lake Erie Railroad. It was sold to the Duluth, Missabe and Iron Range Railway in 1951. (Ernest W. Casbohm collection.)

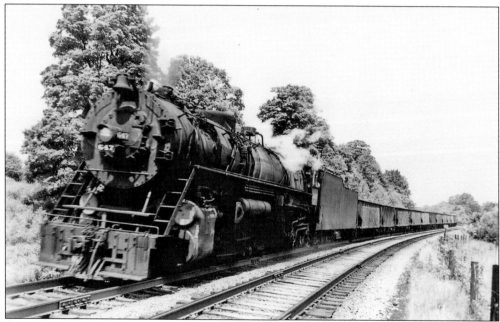

Bessemer and Lake Erie Railroad locomotive No. 647 is hauling a train of hopper cars. Built by Baldwin Locomotive Works in February 1944, this was the last of the Texas-type locomotive number series 601 to 647. It was sold to the Duluth, Missabe and Iron Range Railway in 1951. (Marty Magdich collection.)

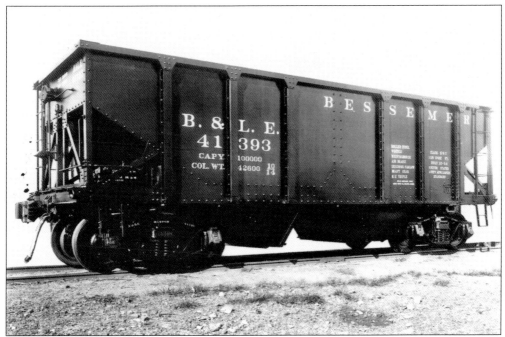

Car No. 41393 is one of 250 steel hopper cars numbered 41251 to 41500 built during 1914 by Ralston Steel Car Company of Columbus, Ohio, for the Bessemer and Lake Erie Railroad. It had rolled steel wheels, Westinghouse air brakes, and a capacity of 50 tons. (Greenville Railroad Park collection.)

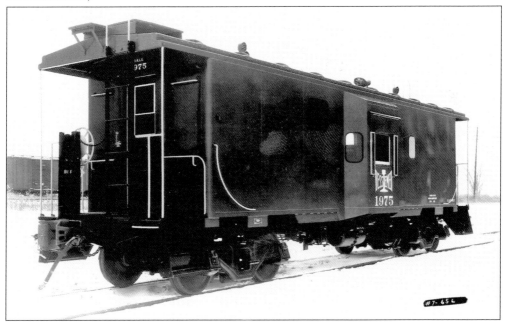

Bessemer and Lake Erie Railroad class NE2 caboose No. 1975 is in the snow. This was one of five cabooses numbered 1971 to 1975 built by Morrison International Corporation during 1960. These all-steel cabooses weighed 52,000 pounds and had a bay window on each side. (Greenville Railroad Park collection.)

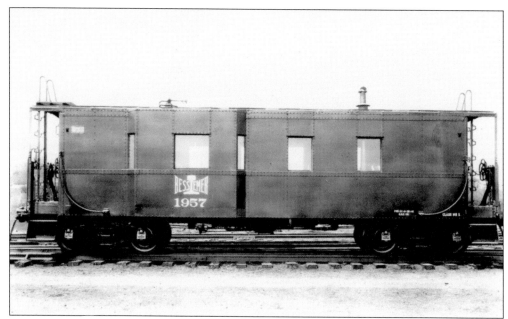

Class NE1 bay window caboose No. 1957 is one of 20 cabooses numbered 1951 to 1970 built by Greenville Steel Car Company during 1941 for the Bessemer and Lake Erie Railroad. The all-steel caboose was 37.53 feet long, was 10.33 feet wide over the bay section, and weighed 58,600 pounds. It was equipped with four bunks to accommodate a crew of four. (Greenville Railroad Park collection.)

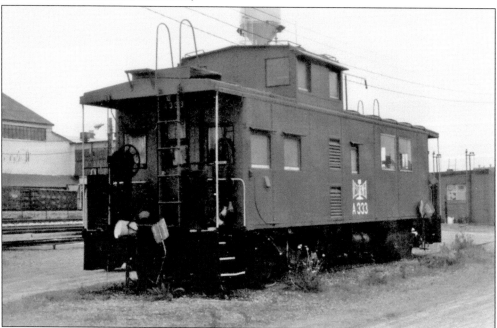

The Greenville yard is the scene for Bessemer and Lake Erie Railroad caboose No. A333. This caboose has a cupola, which is a small windowed projection on the roof, where the crew sat in elevated seats to view the train for shifting loads, broken or dragging equipment, and overheated journal boxes or hotboxes. (Greenville Railroad Park collection.)

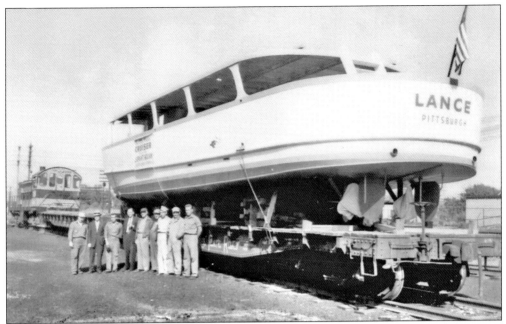

Before beginning the trip, seen here from left to right, J. Grant Nolan, builder and skipper of the pleasure boat *Lance*, poses with the following railroad personnel in Erie on July 18, 1958: L. F. Thompson, Erie agent; R. B. Buie, Erie yard helper; W. M. Mitchell, *Bessemer Bulletin* representative; S. R. Reid, yard engineer; H. W. Fortney, yard foremen; R. K. Greenup, yard fireman; M. P. Podluzne, car man; and L. W. Benn, yard helper. (Albion Area Public Library History Room collection.)

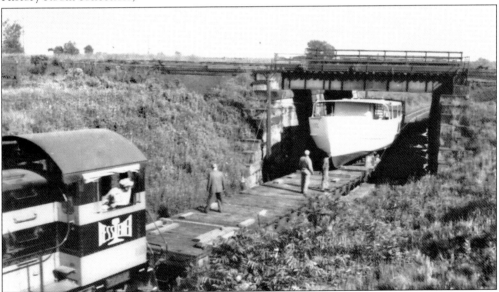

Bessemer and Lake Erie Railroad employees are checking the clearance under the New York Central Railroad and Pennsylvania Railroad tracks in Erie. The Nickel Plate Road moved the boat to Greengarden Road where the Bessemer and Lake Erie Railroad handled the boat to the New York Central Railroad, which delivered the boat to the Pennsylvania Railroad for movement to the Cascade dock in Erie. (Albion Area Public Library History Room collection.)

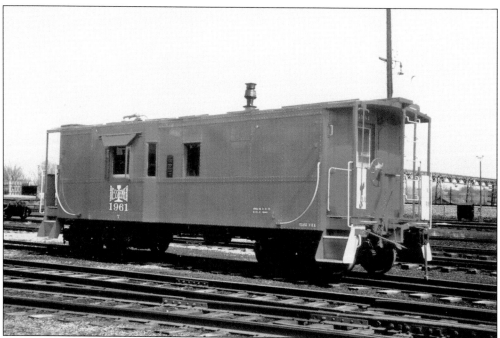

Newly repainted bay window caboose No. 1961 is at the Greenville yard on March 27, 1970. This was one of 20 class NE1 cabooses numbered 1951 to 1970 built for the Bessemer and Lake Erie Railroad during 1941 by Greenville Steel Car Company. The July 1941 *Bessemer Bulletin* notes, "The caboose was intended for use by four men." (Photograph by Kenneth C. Springirth.)

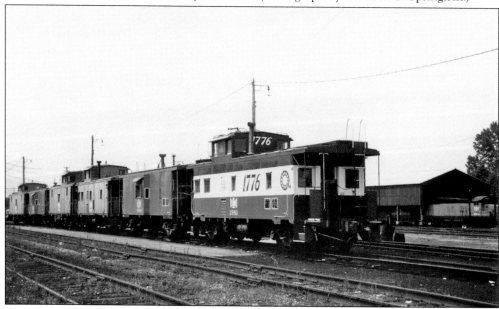

Bessemer and Lake Erie Railroad caboose No. 1981, in a special paint scheme for the United States bicentennial, is at the Albion yard on July 29, 1976. This caboose with a cupola, a windowed projection on the roof, was a standard type while the adjacent caboose was known as a bay window type because the windows set into the extended walls resembled architectural bay windows. (Photograph by Kenneth C. Springirth.)

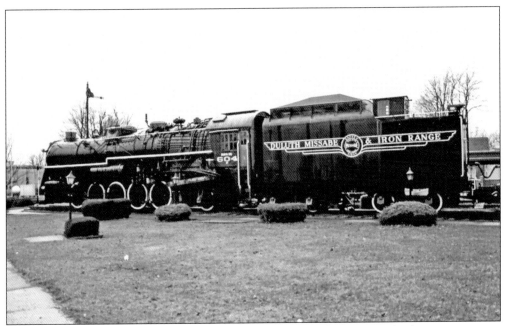

Locomotive No. 604, the world's largest steam switcher, with a 0-10-2 wheel arrangement, is at the Greenville Railroad Park and Museum located at 314 Main Street in Greenville in this March 31, 2008 view. Built by Baldwin Locomotive Works in 1936 for the Union Railroad (Bessemer and Lake Erie Railroad's southern neighbor), it was placed in the Greenville Railroad Park and Museum in March 1985. (Photograph by Kenneth C. Springirth.)

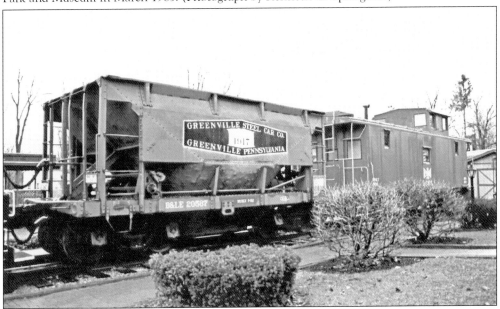

Bessemer and Lake Erie Railroad ore car No. 20567, built in July 1952 by Greenville Steel Car Company, and class NE3 caboose No. 1985, built during 1956 by Morrison International Corporation, are at the Greenville Railroad Park and Museum in this March 31, 2008, scene. The caboose served as a crew car at the Shenango yards at Greenville. (Photograph by Kenneth C. Springirth.)

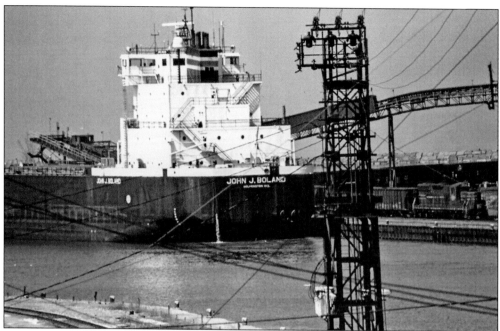

Self-unloading lake bulk carrier *John J. Boland* is at Conneaut harbor on April 18, 2008, transferring iron ore to Bessemer and Lake Erie Railroad hopper cars. This vessel was built by the Bay Shipbuilding Company of Sturgeon Bay, Wisconsin, and launched on March 10, 1973, for the American Steamship Company as the *Charles E. Wilson*. It was renamed the *John J. Boland* in January 2000. (Photograph by Kenneth C. Springirth.)

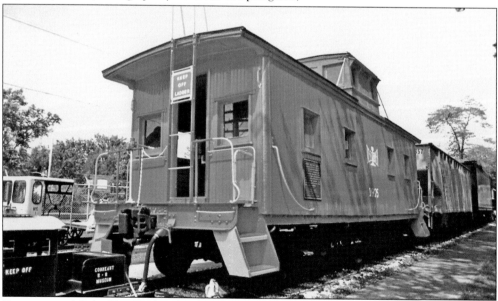

Bessemer and Lake Erie Railroad caboose No. 1825 and hopper car No. 76857 with former Nickel Plate Road steam locomotive No. 755 are in this July 26, 2008, scene at the Conneaut Railroad Museum. This equipment was delivered to the site on October 14, 1964, with the caboose numbered as 1001 (as delivered and later renumbered) and was donated to the city of Conneaut. (Photograph by Kenneth C. Springirth.)

Two

Passenger and Excursion Service

Regular railroad passenger service began on the Shenango and Allegheny Railroad on November 3, 1869, from Greenville to Pardoe, connecting with the Atlantic and Great Western Railroad at Shenango and the Erie and Pittsburgh Railroad at Greenville. Ridership peaked on the Bessemer and Lake Erie Railroad with over 1.1 million passengers carried in 1913. According to the *Bessemer Bulletin*, October 1936 passenger train service to Conneaut Lake Park began in 1893 with as many as 16 trains a day arriving in the summertime, noting, "The trains as they arrived at the Park would be unloaded and moved to Meadville Junction. There the engine and coaches would be serviced and the train parked until time to be moved into the Park for loading on the return journey." The hard economic times of the 1930s and increased usage of automobiles ended passenger service to Conneaut Lake Park in 1934, except for occasional excursion trips. Conneaut-to-Albion passenger train service, which began in August 1892, ended on May 31, 1932. East Pittsburgh-to-North Bessemer passenger train service, which began on May 28, 1906, made the last run on March 29, 1941. May 17, 1952, was the last day of passenger service from Greenville to North Bessemer. Four Pacific-type steam locomotives with a 4-6-2 wheel arrangement built by American Locomotive Company were assigned for passenger service. The first regularly scheduled diesel-powered passenger service began on November 17, 1953. All regular scheduled passenger service ended with the last run from Erie to Greenville on March 5, 1955. The *Erie Dispatch* newspaper of March 6, 1955, reports crowds turned out along the route of the final run noting, "At Girard, Platea, Cranesville, Albion, Springboro, Conneautville, and all other points old friends and patrons waved a final farewell." In the *Bessemer Bulletin* for May 1955, under the headline "A Fine Ending," it is noted, "The crowd was swelled by additional passengers from Erie and, although there was no band at the station to play the national anthem when No. 13 pulled out, many of the nearly 500 passengers stood, as the seats were all occupied long before leaving time."

BESSEMER
Bessemer & Lake Erie R.R. Co.

MAIN LINE TRAINS.

CENTRAL TIME. In Effect Sept. 23, 1900.

SOUTHWARD.	Dist. from Erie	1	9	11	13	23
BUFFALO { via L.S.&M.S. / via N.Y.C.&St.L.		3 20AM / 11 30PM	5 10AM / 6 10	12 20PM / 12 10
ERIE............Lv.	0.0	6 53AM	12 10PM	4 15PM	
West Millcreek....	5.0		f 7 08		4 30	
Swanville.........	8.5		7 13	12 30	f 4 35	
Fairview..........	11.2		7 18	12 35	4 40	
Wallace Junction...	14.4		7 28	12 45	4 50	
Girard............	15.5		7 31	12 48	4 53	
Platea............	20.2		f 7 42	f12 58	f 5 07	
Cranesville......	23.8		7 50	1 07	5 17	
Albion............	24.9		7 56	1 12	5 25	
Shadeland.........	31.3		f 8 08	f 1 24	5 37	
Springboro........	32.5		8 11	1 27	5 40	
Conneautville.....	35.6		8 17	1 33	5 46	
Dicksonburg.......	39.9		8 24	f 1 42	f 5 53	
Harmonsburg......	43.0		f 8 30	f 1 48	f 5 58	
Meadville Junction.	45.0		8 38	1 54	6 05	
Shermansville.....	46.6		f 8 41	f 1 57		
Hartstown.........	52.2		8 52	2 08	6 19	
Adamsville........	55.0		8 58	2 13	6 25	
Osgood...........	60.1		f 9 07	2 20	6 35	
Greenville.........	63.7	6 35AM	9 15	2 30	6 43	
Shenango.........	65.7	6 42	9 20		6 50	
Kremis............	70.8	f 6 51		f 2 47	7 01	
Fredonia..........	74.4	6 57		2 53	7 08	
Coolspring........	76.5	f 7 01			7 12	
Mercer............	82.1	7 13		f 3 11	7 25	
Houston Junction.	81.7	7 19		3 17	7 32	
Pardoe...........	86.1	7 28		3 27	7 40	
Grove City........	91.0	7 40		3 37	7 50	
Carter............	94.9	f 7 48				
Harrisville........	97.6	7 53		f 3 49		
Branchton........	100.2	8 01		3 57		
Keisters...........	102.0	8 05		4 01		
Hallston..........	105.0	8 12		f 4 08		
Claytonia.........	106.2	f 8 14				
Euclid............	109.1	8 20		4 17		
Jamisonville......	112.8	8 28		4 25		
Oneida...........	115.9	8 35		4 31		
Butler............	121.5	8 50		4 45		
Odell.............	125.6				5 05PM	
Meharg...........	129.5					
Turin.............	134.8				4 52	
Houseville........	135.7					
Culmerville.......	142.2				4 07	
Rural Ridge.......	146.8				4 36	
North Bessemer...	154.7				5 22	
BESSEMER........	163.4					
Via P. & W. Ry.			16		26	
Butler, Lv.........			8 58AM		4 50PM	
Renfrew...........			9 10		5 00	
Callery Junction...			9 25		5 20	
Mars..............			9 31		5 27	
Valencia...........			9 34		5 32	
Bakerstown........					5 56	
Sharpsburg........			10 04		6 07	
Allegheny.........			10 20		6 20	
ALLEGHENY--Via West Penn....			11 59AM			

Note—Passengers on train 13 for Shermansville will transfer to train 47 at Meadville Junction. All Trains Daily Except Sunday. f Flag Station. See Page 9 for Connections.

BESSEMER
Bessemer & Lake Erie R.R. Co.

MAIN LINE TRAINS.

CENTRAL TIME. In Effect Sept. 23, 1900.

NORTHWARD.	Dist. from Bessemer	12	14	10	2	22
Allegheny—Via West Penn / Pittsburg—B.&O. Station		6 00AM	1 50PM
Via P. & W. Ry						
Allegheny.........			7 00AM		2 15PM	
Sharpsburg........					2 27	
Bakerstown........						
Valencia...........					2 57	
Mars..............					3 02	
Callery Junction...			7 50		3 15	
Renfrew...........					3 22	
Butler.............			8 12		3 45	
BESSEMER........	0.0					
North Bessemer...	8.7					5 30AM
Rural Ridge.......	16.6					5 57
Culmerville.......	21.2					6 23
Houseville.........	27.7					7 00
Turin.............	28.6					f 7 05
Meharg...........	33.9					7 23
Odell.............	37.8					7 38
Butler............	42.3		8 18AM		4 00PM	7 55
Oneida...........	47.5		8 34		f 4 15	
Jamisonville......	50.6		f 8 40		4 21	
Euclid............	54.3		8 48		4 29	
Claytonia.........	57.2				f 4 35	
Hallston..........	58.4		f 8 57		4 41	
Keisters...........	61.4		9 03		4 47	
Branchton........	63.2		9 08		4 51	
Harrisville........	65.8		f 9 12		4 57	
Carter............	68.5				f 5 03	
Grove City........	72.4	5 25AM	9 28		5 08	
Pardoe...........	77.3	5 34	9 37			
Houston Junction.	81.7	f 5 43	9 45			
Mercer............	83.1	5 49	9 50			
Coolspring........	86.9	f 5 58				
Fredonia..........	89.0	f 6 03	10 07		f 5 43	
Kremis............	92.6	f 6 10	f10 13			
Shenango.........	97.7	6 22	10 26	4 00PM		
Greenville.........	99.7	6 28	10 33	4 07	6 10	
Osgood...........	103.8	f 6 34	f10 40	4 13		
Adamsville........	108.4	.6 43	f10 49	4 22		
Hartstown........	111.2	6 48	f10 54	4 28		
Shermansville.....	116.8	f 6 59	11 05	4 38		
Meadville Junction.	118.4	f 7 05	11 10	4 44		
Harmonsburg......	120.4	f 7 09	f11 14	4 48		
Dicksonburg.......	123.5	f 7 16	f11 20	4 54		
Conneautville.....	127.8	7 23	11 28	5 03		
Springboro........	130.9	7 29	11 35	5 09		
Shadeland.........	132.1	f 7 33	f11 38	f 5 12		
Albion............	138.5	7 45	11 50	5 23		
Cranesville......	139.6	7 50	11 55	5 28		
Platea............	143.2	f 7 58	f12 03	f 5 43		
Girard............	147.9	8 10	12 15	5 56		
Wallace Junction...	149.0	8 12	12 17	5 58		
Fairview..........	152.2	f 8 22	f12 27	6 08		
Swanville.........	154.9	8 27	12 30	6 11		
West Millcreek....	158.4	8 35	12 38	6 16		
ERIE..............	163.4	8 42	12 50	6 33		
BUFFALO { Via L.S. & M.S. R'y / Via Nickel Plate.		11 45AM	3 55PM / 4 55	10 10PM / 1 45AM

Note—Passengers on train 10 for Linesville will transfer to No. 215 at Shermansville. All Trains Daily Except Sunday. f Flag Station. See Page 9 for Connections.

Bessemer and Lake Erie Railroad main line trains are shown in this September 23, 1900, timetable. Southbound from Erie there were three trains with the 6:53 a.m. train going to Shenango, the 12:10 p.m. train going via Butler to Allegheny (today part of Pittsburgh), and the 4:15 p.m. train going to Grove City. Northbound to Erie there were three trains with the 5:25 a.m. train departing from Grove City, the 6:00 a.m. train departing from Allegheny, and the 4:00 p.m. train departing from Shenango. In essence, there were three trains each way between Erie and Shenango. There was a 6:35 a.m. train from Greenville via Butler to Allegheny and a 1:50 p.m. train from Allegheny via Butler to Greenville. (Ernest W. Casbohm collection.)

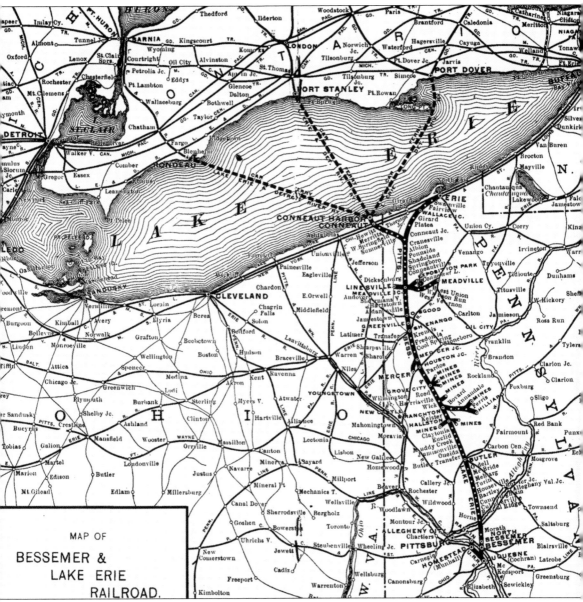

The September 23, 1900, map shows that the Bessemer and Lake Erie Railroad is the most direct north–south railroad from Conneaut and Erie on Lake Erie to Pittsburgh. In western Pennsylvania, it offered a more direct route than the Erie and Pittsburgh Railroad, which later became part of the Pennsylvania Railroad. Branch lines shown on the map that once served Linesville, Exposition Park, Meadville, Hilliards, Mercer, and a number of mines were later abandoned. Roy C. Beaver, former general manager of the Bessemer and Lake Erie Railroad, notes in the *Bessemer Bulletin* of March 1956, "The Bessemer started out in a small way. It went over the hills to the coal fields. From that small beginning it has grown to a major railroad of national importance." (Ernest W. Casbohm collection.)

BESSEMER
Bessemer & Lake Erie R.R. Co.

MEADVILLE, CONNEAUT LAKE & LINESVILLE BRANCH.
In Effect Sept. 23, 1900. CENTRAL TIME.

NORTH-BOUND.

STATIONS	210 Pass.	212 Pass.	214 Pass.	216 Pass.	46 Accom.
Linesville	8 15AM			5 45PM	6 20PM
Shermansville	8 25			5 55	6 30
Meadville Jct. Lv	8 38	11 10AM	1 54PM	6 05	7 05
Exposition } Ar.					
Park } Lv.					
Conneaut Lake	8 48	11 20	2 05	6 16	7 20
Watson's Run	f 9 00	f11 32	f 2 17	f 6 28	
Meadville Ar	9 18	11 50	2 35	6 45	7 50

SOUTH-BOUND.

STATIONS	209 Pass.	211 Pass.	213 Pass.	215 Pass.	47 Accom.
Meadville Lv	6 20AM	10 20AM	1 05PM	3 50PM	5 15PM
Watson's Run	f 6 38	f10 38	f 1 23	f 4 06	
Conneaut Lake	6 50	10 50	1 35	4 18	5 44
Exposition } Ar.					
Park } Lv.					
Meadville Jct. Lv	7 05	11 03	1 45	4 32	6 05
Shermansville	7 10			4 38	6 10
Linesville	7 20			4 48	6 20

HILLIARD BRANCH.

NORTH-BOUND.			STATIONS	SOUTH-BOUND.	
64 Accom.	60 Accom.	Dist. from Branchton		61 Accom.	65 Accom.
3 57PM	8 01AM	0.0	Branchton	9 08AM	4 51PM
3 10	7 25	1.1	Bovard	9 12	5 00
2 50	7 05	6.1	Annandale	9 22	5 20
2 40	6 55	8.2	Ferris	9 32	5 30
2 30	6 45	10.3	Hilliard	9 42	5 40

All trains daily except Sunday. f Flag stations.

BESSEMER
Bessemer & Lake Erie R.R. Co.

CONNEAUT BRANCH.
In Effect Sept. 23, '00. SOUTH-BOUND. CENTRAL TIME.

STATIONS	Dist. from Con. Harbor	109 Accom.	111 Accom.	113 Accom.
Conneaut Harbor	0.0		10 45AM	4 20PM
Conneaut	1.7	7 05AM	11 00	4 32
Hewitt	5.6	f 7 13	f11 10	f 4 41
Merritts	6.7	f 7 16	f11 15	f 4 44
West Springfield	7.9	f 7 20	f11 20	f 4 48
Sumnerville	11.0	f 7 27	f11 27	f 4 55
Lexington	11.8	f 7 29	f11 29	f 4 57
Cranesville	14.6	7 50	11 53	5 17

NORTH-BOUND.

STATIONS	Dist. from Cranesville	112 Accom.	114 Accom.	110 Accom.
Cranesville	0.0	7 50AM	1 07PM	5 33PM
Lexington	2.8	f 7 54	f 1 13	f 5 37
Sumnerville	3.5	f 7 56	f 1 15	f 5 39
West Springfield	6.7	f 8 03	f 1 22	f 5 46
Merritts	7.9	f 8 07	f 1 26	f 5 50
Hewitt	9.0	f 8 10	f 1 29	f 5 53
Conneaut	12.9	8 18	1 38	6 00
Conneaut Harbor	14.6	8 30	1 48	

All trains daily, except Sunday. f Flag stations.

BAGGAGE.

The limit of this Company's liability for lost or stolen baggage (while in this Company's possession) is $100.00, except by special agreement.

One hundred and fifty (150) pounds of baggage (wearing apparel only) for each full fare, and seventy-five (75) pounds for each half fare, is allowed on each first-class local or coupon ticket. All excess weights to be charged for according to the rules of this Company.

No single piece of baggage will be accepted for transportation by this Company in excess of 250 pounds, except by special agreement.

Baggage left at station exceeding twenty-four hours will be charged for as follows:

Trunks, each, 25 cents for every additional 24 hours.
Valises, each, 10 cents for every additional 24 hours.
Sample trunks, each, 25 cents for every additional 24 hours.
Baby Carriages *will not be checked*, but when tagged with name of owner and destination, and accompanied by passenger with infant, may be carried in baggage car free, over this Company's lines only, subject to owner's risk of breakage; otherwise, they must be turned over to the express company.
Bicycles Not Crated will be carried free in baggage car subject to owner's risk of breakage, when accompanied by owners holding first-class tickets. *They must not be checked, but tagged, with owner's name and destination thereon.* If crated, they will be turned over to express company.

The Bessemer and Lake Erie Railroad has convenient passenger service as shown in the September 23, 1900, timetable. There were three trips in each direction between Conneaut and Cranesville. At Cranesville, there were convenient connections north to Erie and southbound to a variety of locations. There were five trips in each direction between Meadville Junction and Meadville, of which three trips operated to and from Linesville on the Meadville, Conneaut Lake, and Linesville branch. There were two trips in each direction on the Hilliard branch between Branchton and Hilliard. (Ernest W. Casbohm collection.)

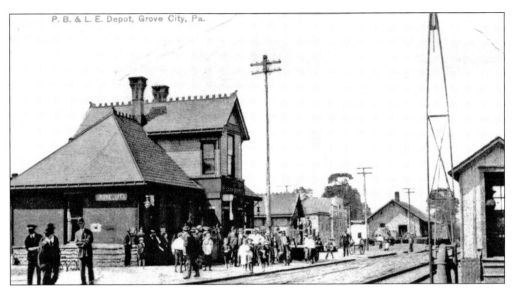

The Pittsburgh, Bessemer and Lake Erie Railroad depot in Grove City is a busy place. Before the advent of paved roads, railroad passenger trains were the principal means of travel. In later years, Harmony Short Line operated bus service from Grove City to Pittsburgh with the April 27, 1947, schedule showing 11 trips from Pittsburgh to Grove City and 9 trips from Grove City to Pittsburgh. (Greenville Railroad Park collection.)

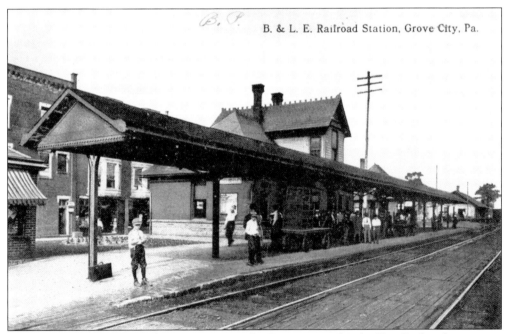

Passengers are waiting for the next train at the Bessemer and Lake Erie Railroad station in the borough of Grove City in this postcard postmarked October 12, 1914. The March 5, 1888, employee timetable showed northbound first-class passenger trains stropping at Grove City at 7:02 a.m., 10:46 a.m., and 4:55 p.m. and southbound first-class passenger trains stopping at Grove City at 7:50 a.m., 12:10 p.m., and 7:11 p.m.

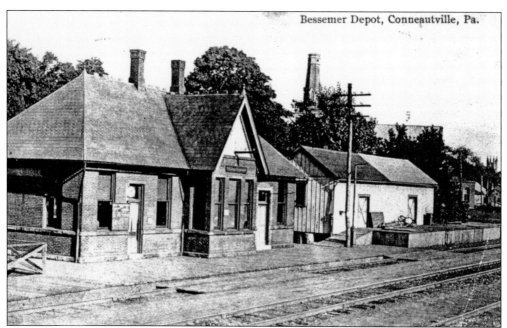

The Bessemer and Lake Erie Railroad depot at the borough of Conneautville is shown with the maintenance storage shed and freight loading dock on the right side of the picture. The railroad provided passenger service until March 5, 1955, that linked Conneautville north to Erie and south to Greenville and in earlier years to North Bessemer. (Ernest W. Casbohm collection.)

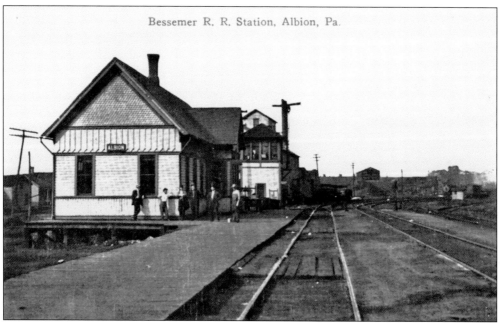

The Albion station of the Bessemer and Lake Erie Railroad on Pearl Street is near the Albion yard in this postcard postmarked June 23, 1915. This was a transfer point for the Conneaut-to-Albion passenger train service connecting with the north–south passenger service from Erie to North Bessemer.

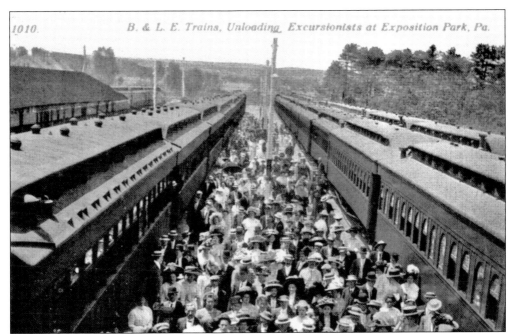

Hundreds of excursionists are arriving by passenger cars on the Bessemer and Lake Erie Railroad at Exposition Park in this postcard postmarked September 7, 1914. Later known as Conneaut Lake Park, this was a popular summer vacation destination for visitors from western Pennsylvania and eastern Ohio. The first excursion train to the park arrived from Pittsburgh in 1893. (Ernest W. Casbohm collection.)

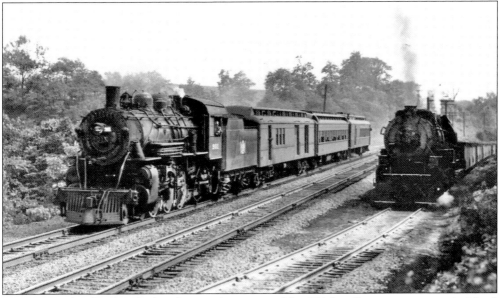

Bessemer and Lake Erie Railroad steam locomotive No. 901 handling passenger train No. 2 passes steam locomotive No. 516 with a coal train coming off the Indianola branch near River Valley on June 30, 1945. Pacific-type locomotive No. 901 was built by American Locomotive Company in 1913. Santa Fe–type locomotive No. 516 was built by Baldwin Locomotive Works in 1916. (Greenville Railroad Park collection.)

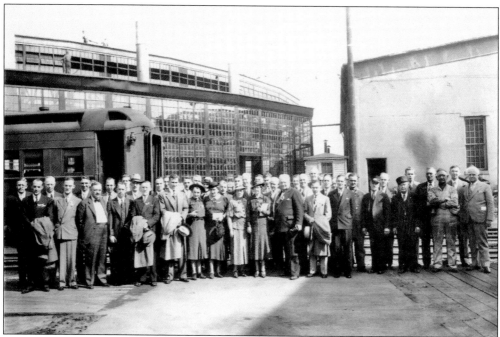

Employees of the Bessemer and Lake Erie Railroad from the Pittsburgh office are at Greenville shops on an inspection trip on September 23, 1937. These trips were educational experiences for office employees, who gained a better insight into the railroad operations and fostered the railroad's goal of continuous improvement. (Marty Magdich collection.)

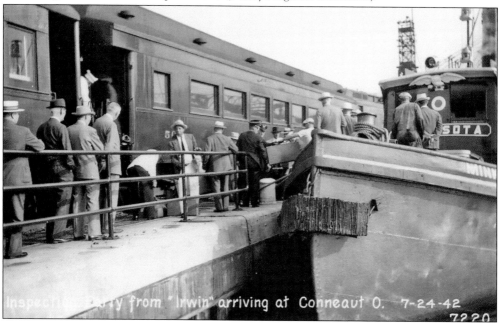

A Bessemer and Lake Erie Railroad inspection party from Irwin, as noted, has arrived at Conneaut on July 24, 1942. The trips were well organized to cover all aspects of the equipment, shops, and yard functions to broaden employee understanding with a goal of being able to better work with railroad customers. (Marty Magdich collection.)

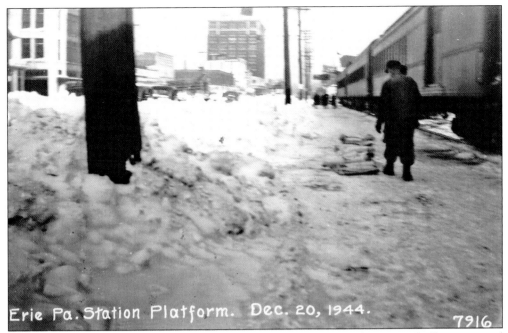

On December 20, 1944, a heavy winter snow has covered Erie in this view of a Bessemer and Lake Erie Railroad passenger train parked parallel to the snowbanks of West Twelfth Street near Peach Street looking east to downtown Erie. The tall building in the center known as the Commerce Building, located at Twelfth and State Streets, was demolished during 1989. (Marty Magdich collection.)

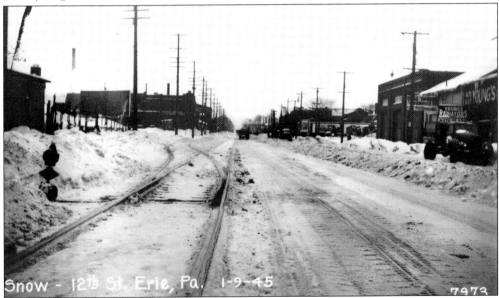

Looking west from the Bessemer and Lake Erie Railroad passenger station in Erie, the track is on the south side of West Twelfth Street. The widening of West Twelfth Street necessitated the abandonment of 1.28 miles of track along West Twelfth Street during 1965. A new interchange track with the New York Central Railroad at West Sixteenth and Cranberry Streets went into service on October 12, 1965. (Marty Magdich collection.)

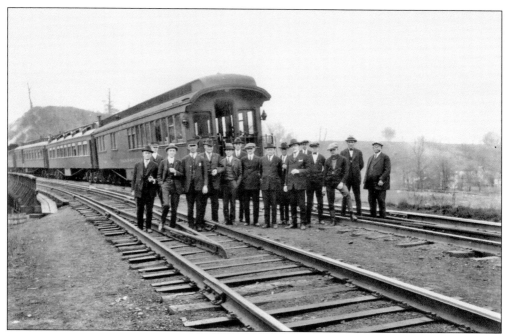

A Bessemer and Lake Erie Railroad inspection tour is being conducted on April 28, 1924. The railroad had inspections by representatives of various departments to acquaint office personnel with the railroad and its employees. These tours looked at all aspects of the railroad, promoted safety, and were used to encourage interdepartmental cooperation. (Marty Magdich collection.)

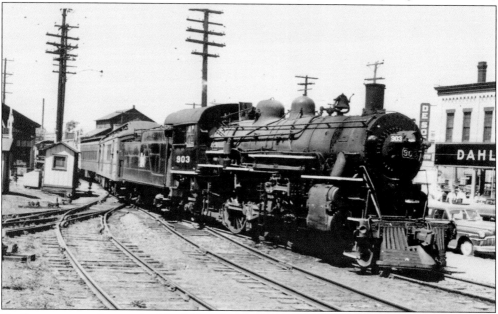

Pacific-type steam locomotive No. 903 with a 4-6-2 wheel arrangement is bringing a Bessemer and Lake Erie Railroad passenger train into Erie during July 1952. The railroad was on the south side of West Twelfth Street and ended near Peach Street. None of the buildings in this picture have survived, and trackage along this portion of Twelfth Street was later removed. (Greenville Railroad Park collection.)

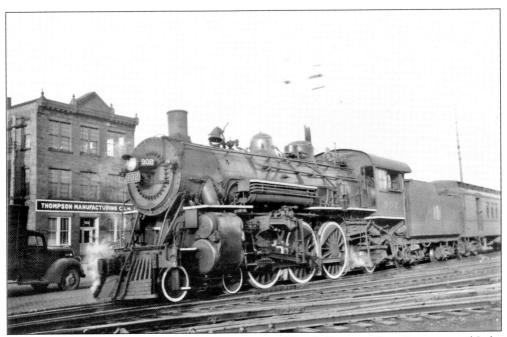

On the south side of West Twelfth Street just west of Peach Street in Erie, Bessemer and Lake Erie Railroad locomotive No. 902 is ready for departure time for the local passenger train from Erie to Greenville in May 1936. In 2008, the building on the left side of the picture has survived. (Greenville Railroad Park collection.)

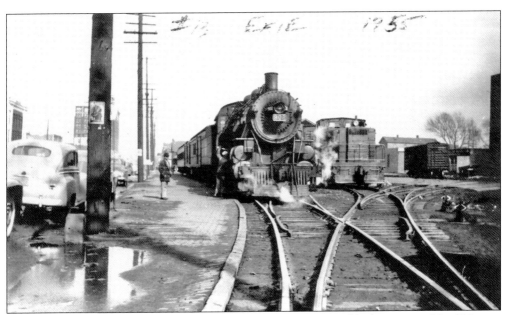

Bessemer and Lake Erie Railroad passenger train No. 13, powered by locomotive No. 902, is at the Erie train station on the south side of West Twelfth Street at Peach Street. This was the railroad's northernmost terminal point in Pennsylvania. The diesel switcher on the right side of the locomotive is waiting for the train to leave. (Greenville Railroad Park collection.)

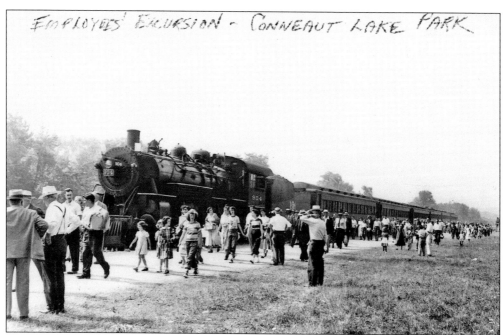

An employees' excursion powered by locomotive No. 904 has brought a large crowd of Bessemer and Lake Erie Railroad employees and their families to Conneaut Lake Park. This was a pleasant way to travel to the park and made a great summer outing that contributed to employee pride. (Greenville Railroad Park collection.)

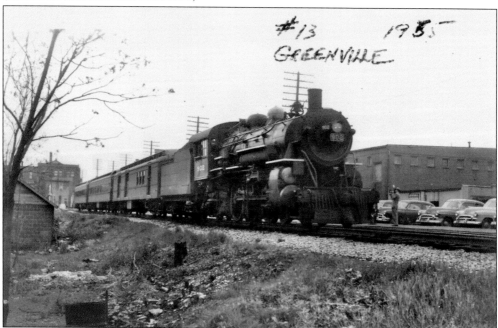

Locomotive No. 902 is powering a three-car Bessemer and Lake Erie Railroad passenger train at Greenville. Before the advent of paved highways, most people traveled by passenger train as it provided dependable accessibility to numerous western Pennsylvania communities plus a rail linkage to the rest of the country. (Greenville Railroad Park collection.)

Bessemer and Lake Erie Railroad Company

R. T. ROSSELL, President, Pittsburgh, Pa.
F. I. SNYDER, Vice-President and General Manager, "
R. W. KEPLER, Secretary and Treasurer, "
R. H. KEYSER, Asst. Treasurer and Asst. Secretary, "
J. S. LEET, Assistant General Manager, "
WM. M. JOHNSON, General Superintendent, Greenville, Pa.
O. JONES, Supervising Agent, "
E. J. McGEARY, Superintendent, "
C. F. WILLIAMS, Assistant Superintendent, "
J. D. CHITTENDEN, Supt. of Transportation, Pittsburgh, Pa.
F. R. LAYNG, Chief Engineer, Greenville, Pa.
GUY M. GRAY, Superintendent of Motive Power, "
EDW. CAMPBELL, Traffic Manager, Pittsburgh, Pa.
L. S. WOLFORD, General Freight Agent, "
L. J. ROBINSON, Assistant General Freight Agent, "
J. O. SHOWALTER, Freight Claim Agent, "
R. B. KRICHBAUM, Passenger Representative, "
C. O. McKALIP, General Auditor, "
J. W. McCOY, Assistant General Auditor, "
W. CHAMPION, Auditor Freight and Passenger Revenue, "
J. O. WHITEMAN, Superintendent of Safety and Claims, Greenville, Pa.
J. W. BROWN, M.D., Chief Surgeon, "
REED, SMITH, SHAW & McCLAY, General Counsel, Pittsburgh, Pa.
THOMAS R. DICKINSON, Purchasing Agent, "

General Offices—Pittsburgh and Greenville, Pa.
All mail for Pittsburgh office should be addressed to P. O. Box No. 536, Pittsburgh, Pa.

Total Mileage, 204.7.

BESSEMER AND LAKE ERIE RAILROAD

Read Down Daily Except Sunday | | | | Read Up Daily Except Sunday

13	1	Dis. From Erie	Eastern Standard Time	12	2
PM	AM		APRIL 29, 1951	AM	PM
2 00		0.	Lv...ERIE 12th St. Station...Ar	9 45	
2 26		11.1	FAIRVIEW	9 15	
2 39		15.5	GIRARD	9 03	
2 48		20.4	PLATEA	8 53	
2 54		23.8	CRANESVILLE	8 47	
2 59		24.8	ALBION	8 44	
3 05		28.6	PENNSIDE	8 34	
f 3 09		31.3	SHADELAND	f 8 30	
3 12		32.5	SPRINGBORO	8 28	
3 18		35.5	CONNEAUTVILLE	8 22	
f 3 24		39.6	DICKSONBURG	f 8 13	
3 35		45.9	SHERMANSVILLE	8 03	
3 42		51.5	HARTSTOWN	7 49	
3 47		54.3	ADAMSVILLE	7 44	
f 3 56		59.3	OSGOOD	f 7 37	
4 05	7 00	62.9	GREENVILLE	7 30	7 10
	7 18	73.5	FREDONIA		6 52
	7 34	81.0	MERCER		6 40
	7 45	85.1	PARDOE		6 28
	7 58	90.1	GROVE CITY		6 21
	8 07	96.2	HARRISVILLE		f 6 12
	8 12	98.8	BRANCHTON		6 07
	8 17	100.7	KEISTERS		6 03
	f 8 21	103.7	HALLSTON		f 5 59
	f 8 24	105.2	CLAYTONIA		f 5 56
	8 28	107.9	EUCLID		5 52
	8 32	109.6	QUEEN JCT.		5 48
	f 8 41	115.6	ONEIDA		f 5 39
	8 52	119.5	BUTLER		5 30
	f 9 07	129.7	ROCKDALE		f 5 12
	9 15	135.6	IVYWOOD		5 04
	f 9 20	138.5	CUNNINGHAM		f 5 00
	9 22	140.0	CULMERVILLE		4 58
	9 26	141.7	CURTISVILLE		4 54
	9 29	142.8	RUSSELLTON		4 51
	9 32	145.4	RURAL RIDGE		f 4 47
	f 9 37	148.2	RIVER VALLEY		f 4 43
	9 46	152.6	UNITY JCT.		4 35
	9 48	152.9	Ar...NORTH BESSEMER...Lv		4 30
PM	AM			AM	PM

Reference Marks: f-Flag Stop, train stops only on notice to agent or conductor. Light face type indicates A. M. time. Heavy face type indicates P. M. time.

INFORMATION

NOT RESPONSIBLE—This Company will not assume any responsibility for errors in time tables, inconvenience or damage resulting from delayed trains or failure to make connections; schedules herein are subject to change without notice.

CHILDREN under 5 years of age free, when accompanied by parent or guardian; 5 years of age and under 12, one-half fare; 12 years of age or over, full fare.

ADJUSTMENT OF FARES—In case of dispute with conductors or agents, pay the fare required, take receipt and communicate with Passenger Representative.

REDEMPTION OF TICKETS—Tickets unused or partly used will be redeemed under tariff regulations at proper value.

LOST ARTICLES to be inquired for at office of General Superintendent, Greenville, Pa.

NO RESPONSIBILITY is assumed for articles left in stations or cars.

J. C. BAILEY
General Manager

R. B. KRICHBAUM
Passenger Representative

700 Union Trust Building, P. O. Box 536, Pittsburgh 30, Pa

On the left side of the page, the April 27, 1936, schedule in *The Official Guide of the Railways* for August 1936, published by National Railway Publications Company of New York City, shows the passenger timetable of the Bessemer and Lake Erie Railroad. Service was daily except Sunday. Train No. 13 left Erie at 3:20 p.m. arriving at Greenville at 5:25 p.m. Train No. 12 left Greenville at 7:20 a.m. arriving at Erie at 9:25 a.m. Train No. 1 left Greenville at 7:00 a.m., arrived at North Bessemer at 10:00 a.m., and arrived at East Pittsburgh at 10:28 a.m. Northbound train No. 2 left East Pittsburgh at 3:35 p.m., arriving at North Bessemer at 4:05 p.m. and Greenville at 7:07 p.m. There was a morning train that left North Bessemer at 6:29 a.m., arriving at East Pittsburgh at 7:00 a.m. It left East Pittsburgh at 7:16 a.m. and arrived at North Bessemer at 7:37 a.m. The April 29, 1951, timetable (on the right) shows train service from Erie to Greenville and Greenville to North Bessemer. Train service south of North Bessemer had been discontinued.

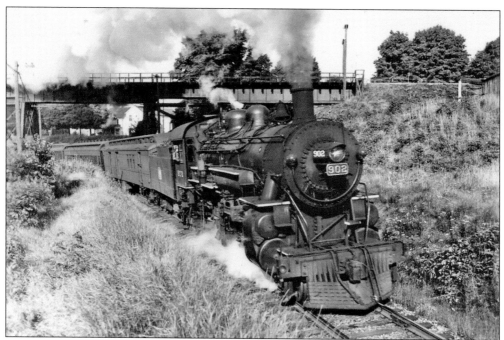

Bessemer and Lake Erie Railroad passenger train No. 12 is at Osgood heading north to Erie on the last day of steam locomotive passenger operation on November 15, 1952. Diesel locomotive passenger service began on November 17, 1952. Locomotive No. 902 was a Pacific-type class P1A with a 4-6-2 wheel arrangement built by American Locomotive Company during 1913. (Ernest W. Casbohm collection.)

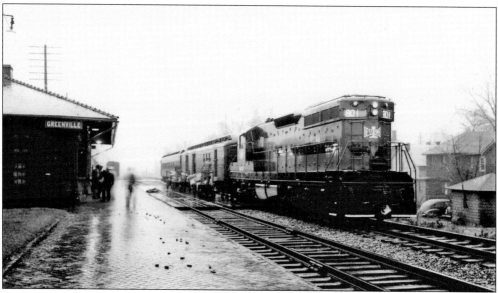

The first diesel-powered Bessemer and Lake Erie Railroad passenger train, No. 12, is ready to leave Greenville at 7:30 a.m. on Monday, November 17, 1952. Class W5A locomotive No. 801 was one of three 1,500-horsepower type SD-7, six-axle road switchers built by the Electro-Motive Division of General Motors Corporation in 1952 with a top speed of 65 miles per hour for passenger service. (Greenville Railroad Park collection.)

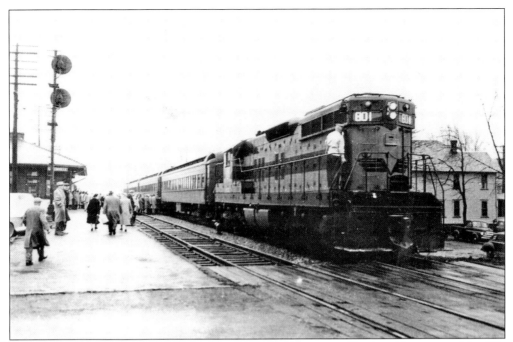

Bessemer and Lake Erie Railroad passenger train No. 12, powered by diesel locomotive No. 801, is loading passengers at Greenville for the last trip to Erie on March 5, 1955. With passenger ridership declining over the years, it was no longer financially possible to continue the service. (Ernest W. Casbohm collection.)

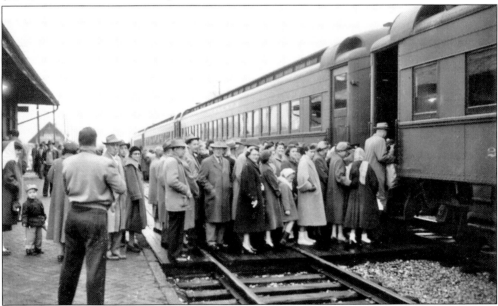

Train No. 12 is loading Bessemer and Lake Erie Railroad employees, their families, and rail enthusiasts at Greenville for the last day of passenger service on March 5, 1955. At Erie, train No. 13 left for the return trip to Greenville with almost 500 passengers. As the train headed south, people waved good-bye at Girard, Platea, Cranesville, Albion, Springboro, Conneautville, and other points. (Greenville Railroad Park collection.)

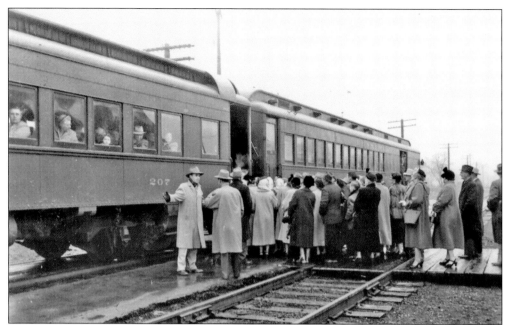

Bessemer and Lake Erie Railroad train No. 12 stops at Albion on its northbound trip to Erie on the last day of regular passenger service, March 5, 1955. Passengers are boarding passenger car No. 207. The *Bessemer Bulletin* of May 1955 notes, "The nostalgic ending of a tradition was softened by the goodwill of passengers and railroad representatives." (Greenville Railroad Park collection.)

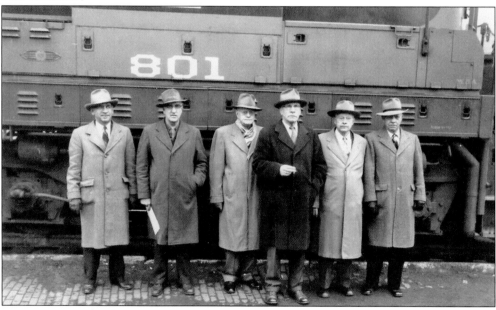

Six Bessemer and Lake Erie Railroad retirees are posing alongside diesel locomotive No. 801 on March 5, 1955, the last day of regularly scheduled passenger service. From left to right are L. A. Stetzer, captain of police; S. R. Reid, engineer; J. H. Eastlake, railroad dispatcher at Greenville; J. L. Gunter, sergeant of police; E. R. Smith, railroad dispatcher at Greenville; and J. Q. Cox, yard helper at Erie. (Albion Area Public Library History Room collection.)

A crowd of passengers is on West Twelfth Street, west of Peach Street, in Erie on March 5, 1955, the last day of regular scheduled passenger service on the Bessemer and Lake Erie Railroad. Train No. 12 arrived in Erie from Greenville with a seated load. Train No. 13 left Erie for Greenville with almost 500 passengers. (Greenville Railroad Park collection.)

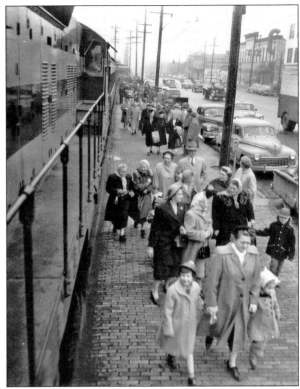

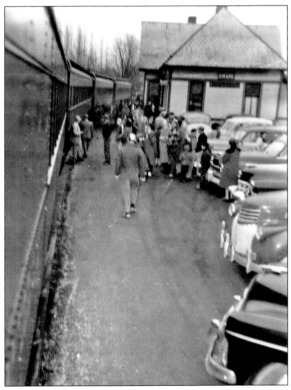

Southbound train No. 13 is at Girard on March 5, 1955, for the last trip to Greenville. This was the end of an era, and residents would no longer be able to set their clocks by the train. On the trip back to Greenville, residents and visitors waved goodbye to the train. (Greenville Railroad Park collection.)

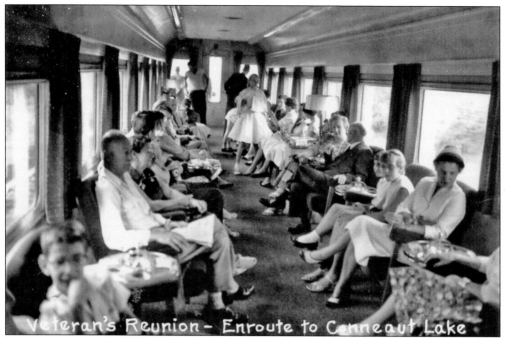

Passengers are having a pleasant ride in a Bessemer and Lake Erie Railroad observation car to Conneaut Lake Park for a retired employees' reunion that was open to all employees on August 18, 1956. This was an excellent summer outing with the train saving long-distance driving for employees from the Pittsburgh area. (Marty Magdich collection.)

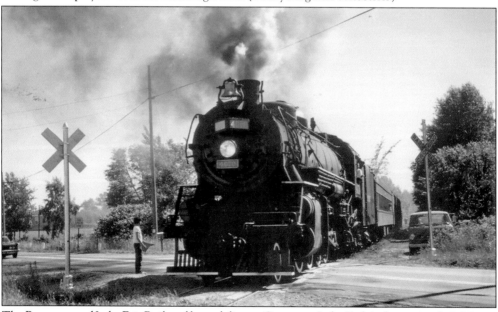

The Bessemer and Lake Erie Railroad branch line to Conneaut Lake Park is the setting for Midwest Railway Preservation Society steam locomotive No. 4070 crossing Pennsylvania Highway 618 on July 17, 1971. American Locomotive Company built the Mikado-type locomotive with a 2-8-2 wheel arrangement in 1918 for the Grand Trunk Western Railroad as No. 3734. This trackage was later removed. (Photograph by Kenneth C. Springirth.)

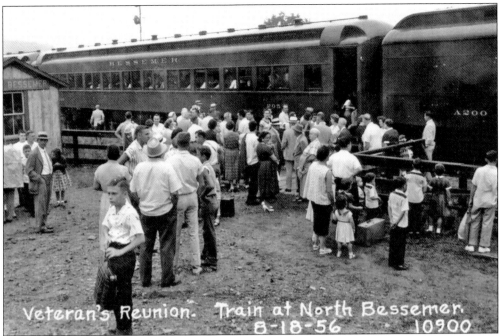

On August 18, 1956, a special train loads passengers at North Bessemer for the Bessemer and Lake Erie Railroad's veterans' reunion at Conneaut Lake Park. The special train service continued up to 1964 when passenger cars were obtained from two separate railroads. With the abandonment of Pennsylvania Railroad commuter service in Pittsburgh and the scrapping of its passenger cars, the special train was discontinued in 1965. (Marty Magdich collection.)

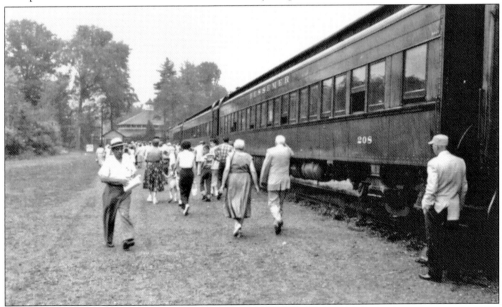

The special veterans' reunion train unloads passengers at Conneaut Lake Park on August 18, 1956. Because of the difficulty in securing passenger cars for the picnic special, the June 1965 *Bessemer Bulletin* notes, "The customary special train between North Bessemer and Conneaut Lake Park will not run for the August 28 Annual Outing." (Marty Magdich collection.)

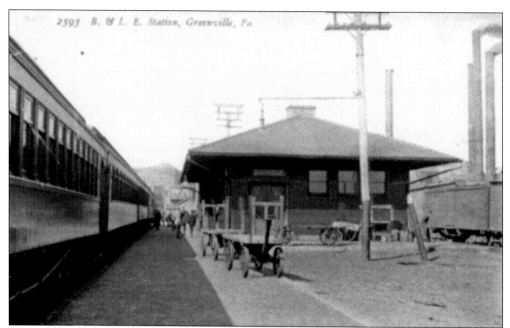

This is a postcard view of the Bessemer and Lake Erie Railroad passenger station in Greenville. The 30-foot-wide-by-72-foot-long station was built by Leech and Smith of Greenville for $7,657 and opened in 1901. After passenger service was discontinued on March 5, 1955, John Read, railroad general manager, had the building renovated to serve as his office.

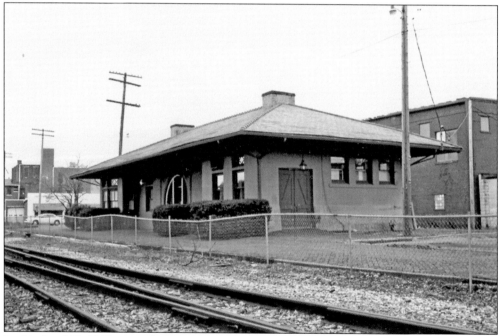

In this April 19, 2008, view, the Bessemer and Lake Erie Railroad passenger station in Greenville is used by two commercial enterprises. This is the last surviving brick and stone passenger station on the Bessemer and Lake Erie Railroad. The well-constructed station exemplified a well-run railroad and has weathered time and a variety of uses. (Photograph by Kenneth C. Springirth.)

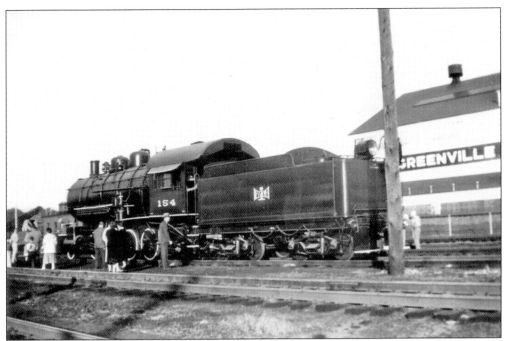

The Greenville yard is the scene for Consolidation-type locomotive No. 154 during a stopover by the Midwest chapter of the National Railway Historical Society fall excursion of October 12, 1958. Baldwin Locomotive Works built this locomotive in April 1909. It was retired in 1953 and has survived. About 900 passengers traveled on the Bessemer and Lake Erie Railroad from Shenango to North Bessemer and return. (Greenville Railroad Park collection.)

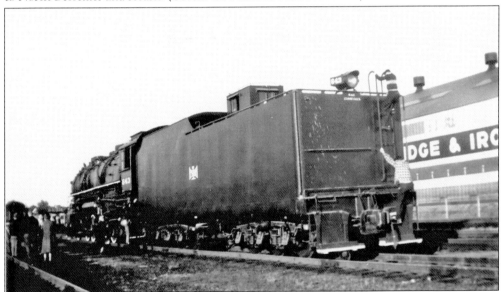

On October 12, 1958, Midwest chapter of the National Railway Historical Society excursionists view Texas-type locomotive No. 643 at the Greenville yard. An Erie Railroad passenger train left separately from Akron and Cleveland and merged into one 15-car train at Youngstown, Ohio, traveling to Shenango where the Bessemer and Lake Erie Railroad took over to North Bessemer with a stop at Greenville on the return. (Greenville Railroad Park collection.)

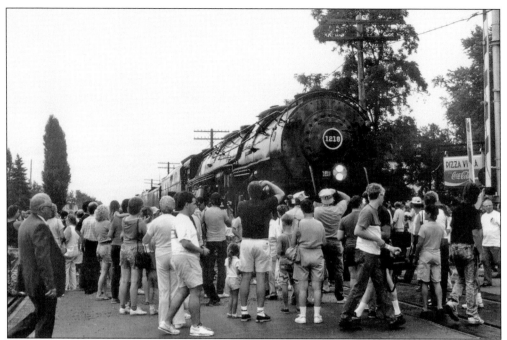

Steam locomotive No. 1218 with a 2-6-6-4 wheel arrangement is powering a Niagara Frontier chapter of the National Railway Historical Society excursion on the Bessemer and Lake Erie Railroad at Albion (originating from Buffalo, New York) on August 11, 1990. Built by the Norfolk and Western Railway during 1943 and retired in 1959, it was restored after the 1982 Southern Railway merger creating the Norfolk Southern Railway. (Photograph by Kenneth C. Springirth.)

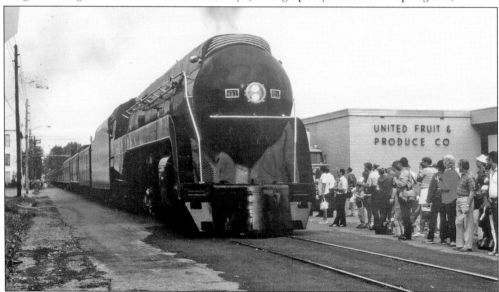

On August 11, 1984, streamlined steam locomotive No. 611 powers a Lake Shore Railway Historical Society excursion returning from Buffalo on the Norfolk Southern Railway shown on Nineteenth Street in Erie. This locomotive, built by the Norfolk and Western Railway's Roanoke shops in 1950, was retired during 1959. The restored locomotive operated excursions after the 1982 merger creating the Norfolk Southern Railway. (Photograph by Kenneth C. Springirth.)

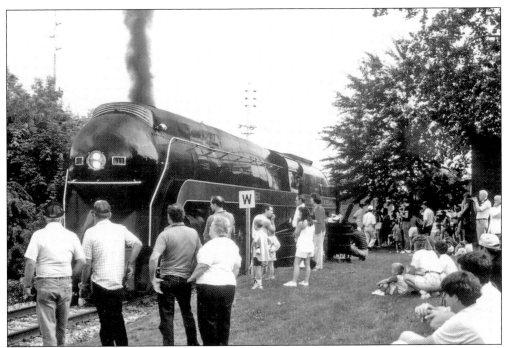

The arrival of Norfolk and Western Railway locomotive No. 611 on the Bessemer and Lake Erie Railroad at Girard on a Niagara Frontier chapter of the National Railway Historical Society rail excursion from Buffalo on July 18, 1992, attracted attention. This was one of 14 class J locomotives numbered 600 to 613 built with a weight of 494,000 pounds and a tractive effort of 80,000 pounds. (Photograph by Kenneth C. Springirth.)

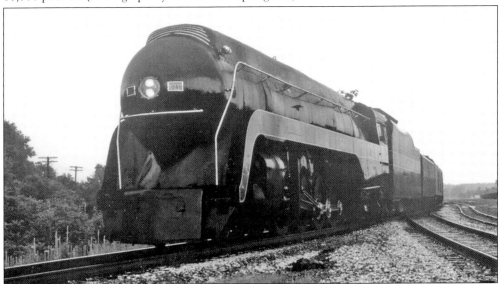

Streamlined black and Tuscan red Norfolk and Western Railway locomotive No. 611 with a 4-8-4 wheel arrangement is at the Bessemer and Lake Erie Railroad yard at Cranesville on a Niagara Frontier chapter of the National Railway Historical Society rail excursion on July 18, 1992. The wye at Cranesville was used to reverse the train for its trip back to Buffalo. (Photograph by Kenneth C. Springirth.)

Main Street at the Bessemer and Lake Erie Railroad crossing in Girard finds Erie Metropolitan Transit Authority route 12 bus No. 9970 westbound at 3:40 p.m. for Albion on June 30, 2008. This bus seating 29 was built by New Flyer Industries during 1999. This is the only section of the northern part of the railroad that has public transit service. (Photograph by Kenneth C. Springirth.)

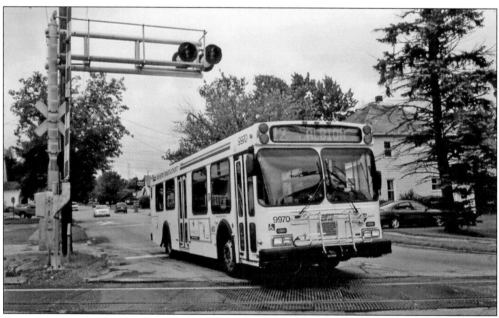

State Street at the Bessemer and Lake Erie Railroad crossing in Albion is the scene for Erie Metropolitan Transit Authority bus No. 9970 on June 30, 2008. In 2008, the Erie-to-Albion route 12 bus operated a morning and afternoon trip on Monday and Thursday with no service on certain holidays. There is no bus service from Erie to Greenville. (Photograph by Kenneth C. Springirth.)

Three

MAINTAINING THE RAILROAD

On the Bessemer and Lake Erie Railroad, rail weighing 100 pounds per yard was standard in 1897, increasing to 130 pounds per yard in 1917 and 155 pounds per yard in 1948. In 1953, steel mills discontinued the 155-pounds-per-yard rail, and the new standard became 140 pounds per yard. The durability of 100-pounds-per-yard rail was 6.5 years, while 130-pounds-per-yard rail could last 13 years. Stiffness was an important factor in the purchase of rail. Higher stiffness reduces deflection under traffic and distributes the load over more ties and over a greater area of the roadbed and ballast. This reduces vertical deformation of the track structure, which lengthens service life of rail, joint bars, ties, and ballast. In 1936, the Thermit welding process was used to weld rail. The rail is surrounded by a sand mold into which is poured the molten metal. It is like a gigantic soldering process joining rails together to achieve a smooth ride (without rail joints) and reduce maintenance expense. Average trainload on the Bessemer and Lake Erie Railroad increased 68 percent, from 2,336 tons in 1929 to 3,936 tons in 1942. To keep track smooth, the ballast must be uniformly compacted under the ties. Hand methods included tamping with shovel, fork, tamping pick, or tamping bar. In May 1949, the Bessemer and Lake Erie Railroad placed a Jackson multiple tamper into operation, which shakes the stone ballast, and the stone is forced in the hole under the tie as the tamping blades are lowered. A crew of 28 to 30 men could complete about 2,000 feet of tamped track per day compared to 800 to 1,000 feet of track using the hand method.

Over the years, the railroad improved track maintenance with the use of power-driven machines, treatment of ties, and heavier high-quality rail to handle increasing trainloads. Proud of their work on the railroad, employees were long-term and stayed until retirement. It was common for many families to have their sons and daughters join the railroad, because it was a great place to work.

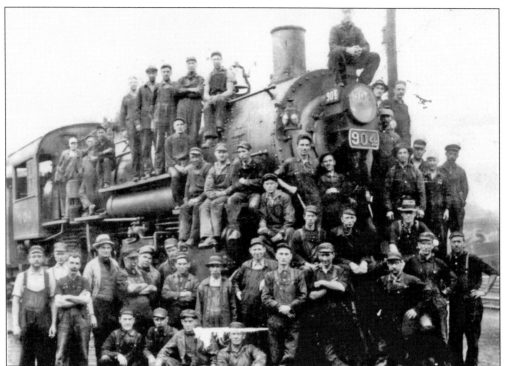

The Greenville roundhouse employees are around Bessemer and Lake Erie Railroad locomotive No. 904 during September 1915. Seated on the headlight is Clyde Kinder. Standing on the running board are, from left to right, Andy Hasenplugh, Al Jaxtheimer, Samuel Mowry, George Becker, Harry Gano, Fred Holmes, Lewis Shaffer, and Ernie Cotton. Seated on the ground are, from left to right, A. Schumaker, Joe Madden, Jesse Stafford, and Max Dorfield. (Albion Area Public Library History Room collection.)

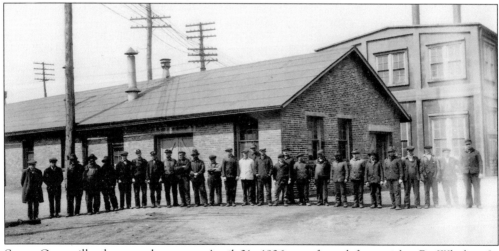

Some Greenville shop employees on April 21, 1926 are, from left to right, R. Whalen, L. Reigelman, J. Urey, M. Bloodworth, J. Torrence, E. Zarecky, F. Loutzenhiser, S. Kosnac, F. Agostini, V. Zarecky, L. Langiotti, L. Loreno, E. Nadasky, S. Coles, D. McBride, A. Mason, J. Woleff, R. McDonald, T. Yanosek, J. Kanyuk, P. Genovesi, E. Benkovsky, J. Koztelnik, A. Locke, N. Wilson, J. Nadasky, J. Kern, and P. McDonald. (Ernest W. Casbohm collection.)

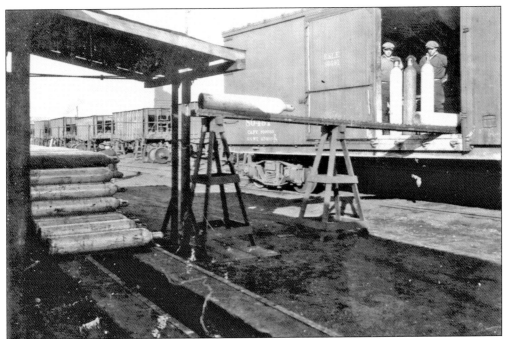

Bessemer and Lake Erie Railroad boxcar No. 80491 is at the Greenville yard hauling gas cylinders. This was one of 291 steel-under-frame boxcars with a 50-ton capacity numbered 80401 to 80691. Standard Steel Works built these for the Union Railroad in 1912. (Ernest W. Casbohm collection.)

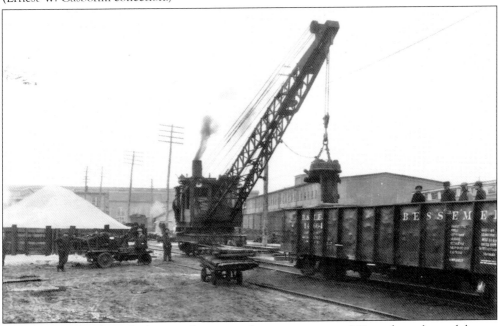

The Greenville shop facility is the scene for steam crane A41 and steel gondola car No. 14664. This was one of 1,000 gondola cars with a 50-ton capacity built by Pressed Steel Car Company in 1914 for the Bessemer and Lake Erie Railroad numbered 14101 to 15100. (Ernest W. Casbohm collection.)

This is a view from the engine house roof of the Greenville shops showing the coach shop, paint shop, powerhouse, and transfer table pit on July 8, 1938. Greenville residents donated 5 acres of land in 1893 and an additional 51.44 acres of land in 1901 to have the shop facilities in Greenville. These were the main railroad shops and were a beehive of activity. (Marty Magdich collection.)

The Bessemer and Lake Erie Railroad yard at the borough of Cranesville shows a passenger train at the station. This was north of Albion, which had car repair and locomotive facilities. The Cranesville yard was a busy facility, in contrast to the quiet area at the same location in 2008. (Ernest W. Casbohm collection.)

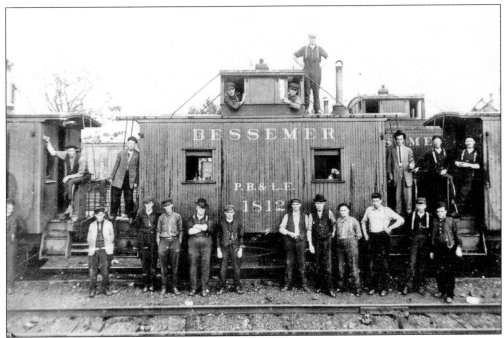

Pittsburgh, Bessemer and Lake Erie Railroad caboose No. 1812 is normally a business office for the train conductor, but a number of people are posing for this photograph. Cabooses were originally all wooden construction like No. 1812. Later cabooses had wood bodies with steel underframes, and by 1941, the Bessemer and Lake Erie Railroad purchased all-steel cabooses. (Ernest W. Casbohm collection.)

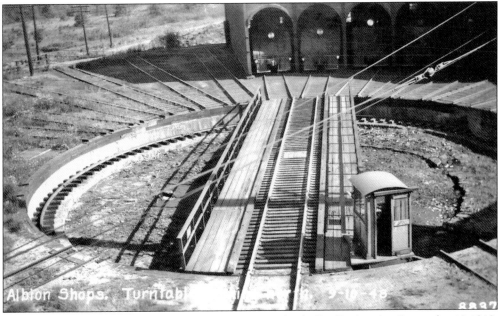

This is a view of the Albion turntable of the Bessemer and Lake Erie Railroad on September 10, 1948. The turntable is a pivoted circular apparatus equipped with track that rotates in a pit and is used to position the locomotive for movement to a different track. (Marty Magdich collection.)

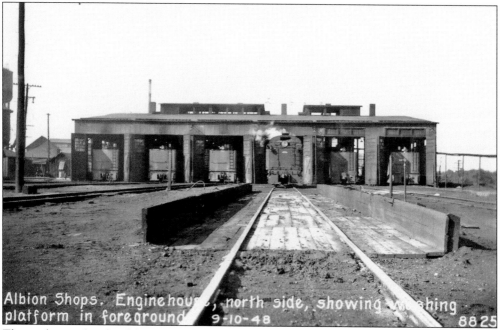

This is the north side of the engine house at Albion on September 10, 1948, with the washing platform in the foreground. All these buildings were later removed. Originally crews worked trains between Conneaut and Albion. Southbound main line trains originated at Albion. Trains to Erie originated at Albion. (Marty Magdich collection.)

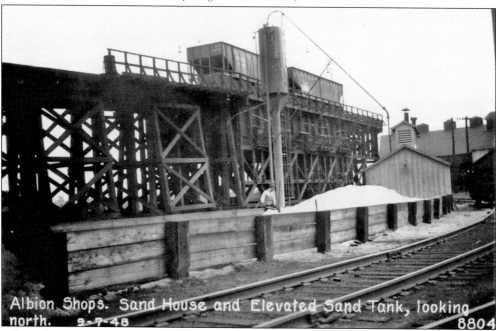

Albion shops, coaling trestle, sand house, and elevated sand tank are in this view looking north on September 7, 1948. These shops were later closed with the Bessemer and Lake Erie Railroad transferring work activity to the Greenville shops. Main line crews are no longer changed at Albion. (Marty Magdich collection.)

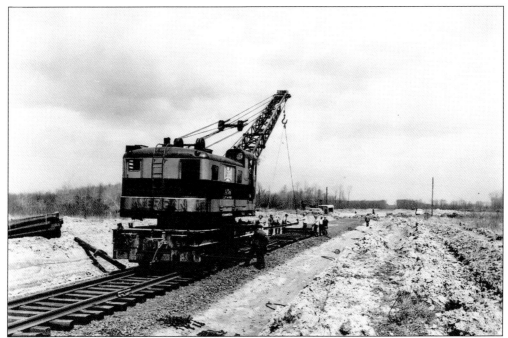

The Conneaut spur from the north end of dock No. 4 in Conneaut eastward 1.79 miles to an ore storage area across the state line into Pennsylvania is under construction using locomotive crane A58. On June 3, 1955, the first Bessemer and Lake Erie Railroad ore train moved over the completed line. (Marty Magdich collection.)

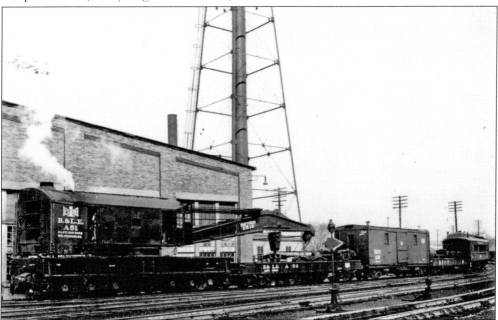

Bessemer and Lake Erie Railroad locomotive crane A51 is at the Greenville yard with flatcar A53 and boxcar A217. Bucyrus Erie Company of South Milwaukee built the crane that was placed in service on August 16, 1937. The crane lifted 200 tons at a radius of 17.5 feet, 119 tons at a radius of 25 feet, and 60 tons at a radius of 30 feet. (Ernest S. Casbohm collection.)

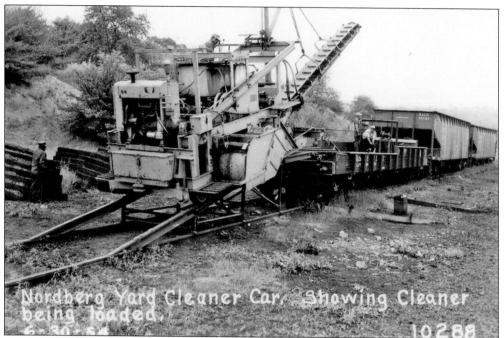

A Nordberg yard cleaning car is being loaded on June 30, 1954. This was used to remove iron ore and debris out of the track area. When dirt builds up on ballast, moisture from rain or snow is less able to drain away from the wooden ties, which can result in tie deterioration. (Marty Magdich collection.)

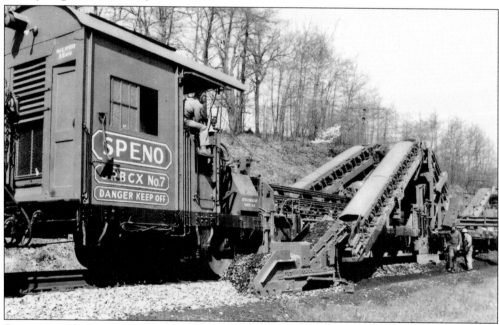

Speno No. 7 ballast cleaner is in use on the Bessemer and Lake Erie Railroad on May 1, 1958. Ballast cleaning was used to curb vegetation growth, improve drainage to prolong the life of the wooden ties, and maintain the load-carrying capacity of the ballast, which served as the foundation for the track. (Marty Magdich collection.)

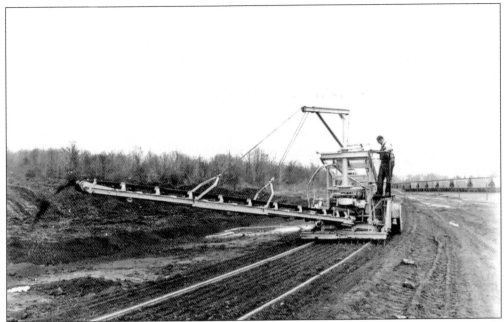

A Nordberg DSL yard cleaner is on the Bessemer and Lake Erie Railroad ore track at Cranesville on April 29, 1953. Wind and rain results in dirt building up and covering the ties. Iron ore shaken out of cars accumulates over a period of time. This machine removed debris out of the track area. Clean track resulted in easier inspection of ties and spikes and aided in weed control. (Marty Magdich collection.)

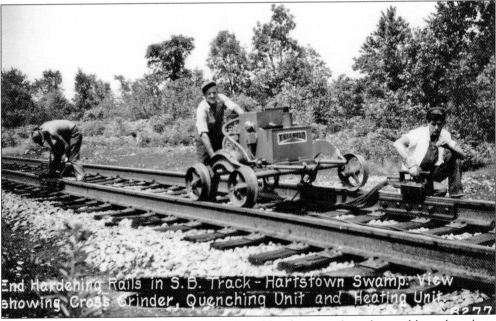

The Bessemer and Lake Erie Railroad crew is end hardening rail on the southbound track on July 5, 1946, at Hartstown swamp in this view showing a cross grinder, quenching unit, and heating unit. Maintaining track integrity resulted in a smoother ride with less wear on rolling stock. (Marty Magdich collection.)

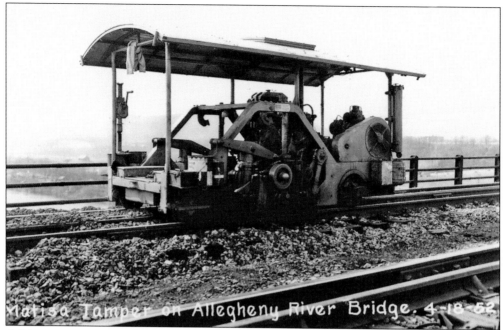

A Matisa tamper is on the Allegheny River bridge on April 18, 1952. This process was used to pack the ballast around the ties plus align the rails to make them parallel and level, which reduced the mechanical strain applied to the rails by passing rains and resulted in a smoother ride. (Marty Magdich collection.)

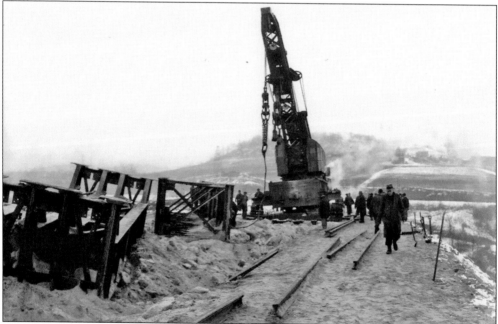

On March 5, 1940, the Bessemer and Lake Erie Railroad crew is taking out girders of the northbound viaduct at Plum Creek, which is north of North Bessemer. To improve safety of operation and movement to and from the North Bessemer yard, the filling of the viaduct was underway by February 11, 1939, and completed around September 21, 1939. (Marty Magdich collection.)

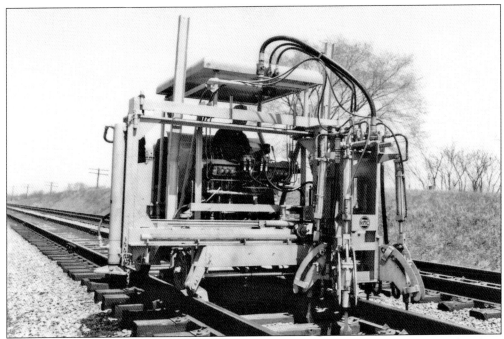

A ballast tamper is seating ballast around ties on the Bessemer and Lake Erie Railroad on May 1, 1958. This was used to achieve a more stable and level track. Benefits of the maintenance program included less potential for derailment and lower train resistance to save on fuel, because the more humps in the track, the more fuel required to get over them. (Marty Magdich collection.)

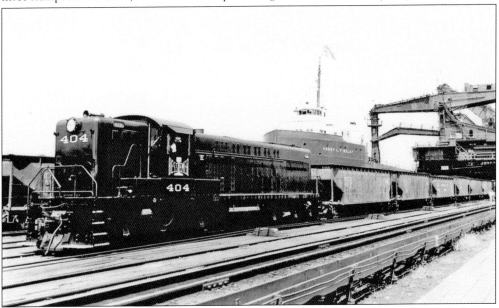

Bessemer and Lake Erie Railroad diesel switcher No. 404 is at Conneaut harbor with the ore boat *Harry L. Findlay* at the dock. This was one of five new 1,500-horsepower diesel switchers numbered 403 to 407 built by Baldwin Locomotive Works of Eddystone during 1950 with a tractive effort of 66,750 pounds and placed in service for yard duty at Albion and Conneaut during 1950. (Marty Magdich collection.)

Looking north, Bessemer and Lake Erie Railroad employees J. C. Kennedy (left) and H. Williams prepare a report where the centralized traffic control system begins near Unity Junction on January 5, 1965. Centralized traffic control, directing train movement by remote-control signal indication, went into operation on June 14, 1956. Track was removed on the right that was no longer needed under the new system. (Greenville Railroad Park collection.)

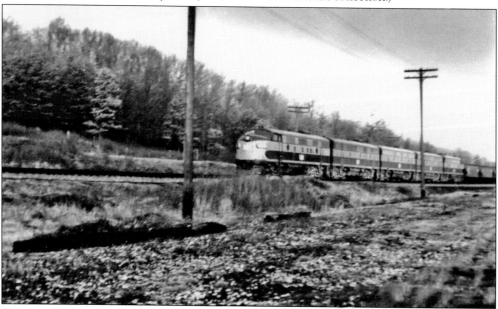

Four type F-7 Bessemer and Lake Erie Railroad diesels are southbound at Coolspring south of the borough of Fredonia on January 6, 1965. In the lower right, two tracks had been removed that were no longer needed under the centralized traffic control system that governed the operation of signals and switches on 135 miles of main line. (Greenville Railroad Park collection.)

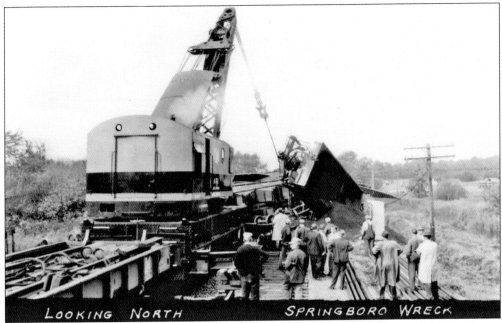

A Bessemer and Lake Erie Railroad locomotive crane is at work clearing the site of the derailment near Springboro on October 7, 1959. The *Bessemer Bulletin* of December 1959 notes, "The wreck, which was caused by a broken journal in the 38th car of the 151 car train, was not cleared until 2:30 a.m. on October 9." (Marty Magdich collection.)

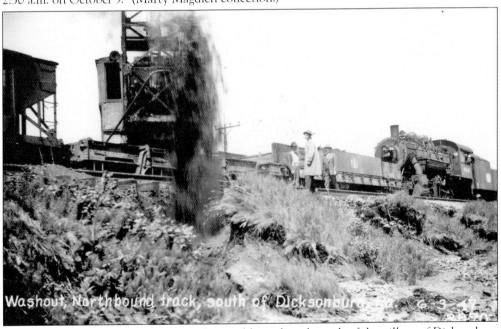

A washout is the scene of activity on the northbound track south of the village of Dicksonburg on June 3, 1947, for the work train powered by Bessemer and Lake Erie Railroad locomotive No. 359. This Consolidation-type locomotive with a 2-8-0 wheel arrangement was built by American Locomotive Company at Schenectady in September 1913 and was scrapped during 1954. (Marty Magdich collection.)

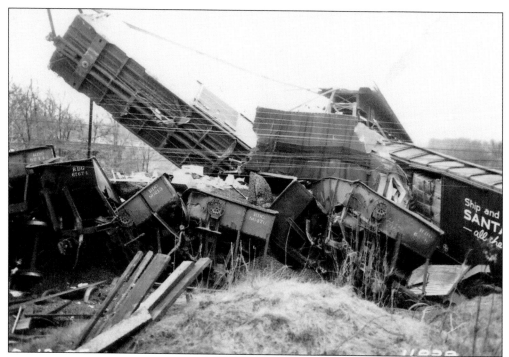

Erie Lackawanna Railroad freight train *Scranton* 99 westbound from Scranton to Chicago derailed with 24 cars piling under the Bessemer and Lake Erie Railroad bridge at Osgood, causing three bridge spans to collapse at 3:15 p.m. on February 13, 1965. In less than 25 hours, Erie Lackawanna Railroad workers replaced 500 feet of track and restored service. (Marty Magdich collection.)

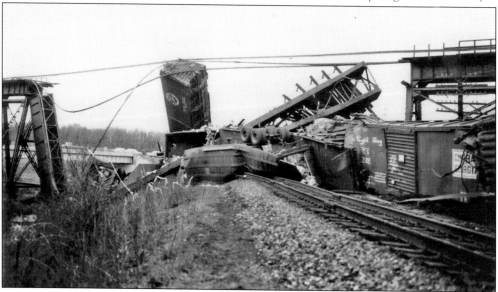

A boxcar pointing into the air is resting against another freight car damaging the Bessemer and Lake Erie Railroad bridge at Osgood with the Erie Lackawanna Railroad derailment of February 13, 1965. American Bridge Company rebuilt the damaged bridge sections. Bessemer and Lake Erie Railroad crews replaced ties and rails, and normal operations resumed at 10:30 p.m. on March 26, 1965. (Marty Magdich collection.)

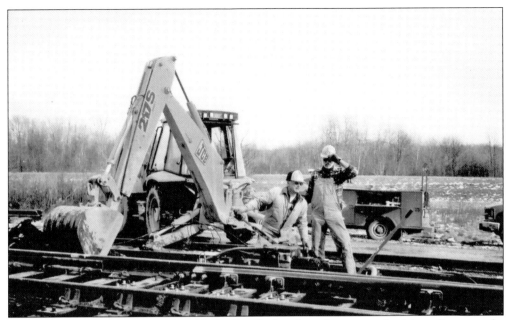

On December 4, 2003, Bessemer and Lake Erie Railroad employees are checking adjustment for operation of a switch near the village of Adamsville. Even with modern equipment, working on the railroad was hard work in all kinds of weather that required skill, resourcefulness, teamwork, and attention to details. (Photograph by Brian C. Sherman.)

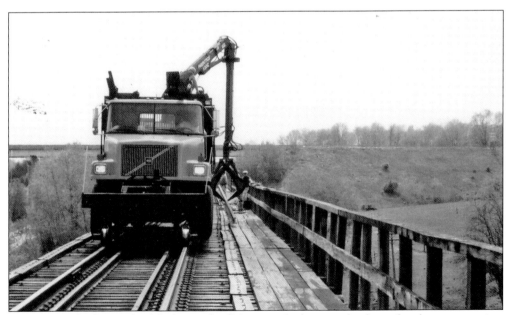

The Kimbles bridge south of the borough of Mercer is the location for this rail replacement project (which required special attention to safety) with the Interstate 79 bridge in the background on May 9, 2004. With heavy-loaded ore cars, track maintenance was important on the Bessemer and Lake Erie Railroad. (Photograph by Brian C. Sherman.)

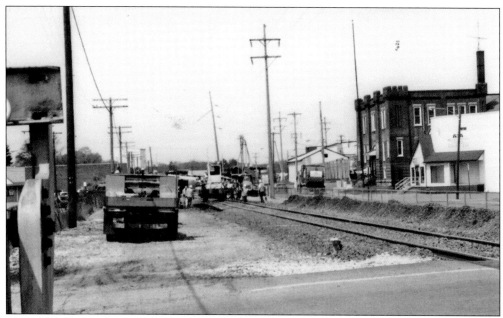

The old ballast is being removed from the tracks between Mill Street and Center Street in Grove City on May 5, 2005. Ballast is replaced periodically to maintain track stability and proper drainage. Over time, the track ballast was crushed by the weight of trains, which could result in uneven track. (Photograph by Brian C. Sherman.)

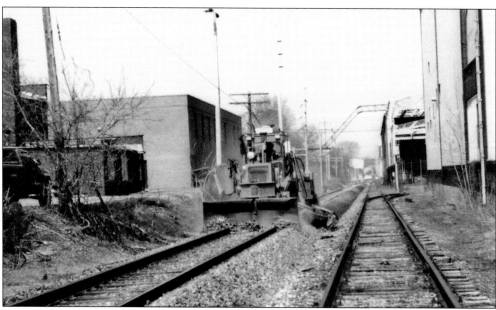

A ballast regulator is distributing the ballast between ties and sweeping ballast from the tops of ties on the Bessemer and Lake Erie Railroad main track at Grove City on May 5, 2005. Historically the railroad was known for its well-maintained right-of-way. (Photograph by Brian C. Sherman.)

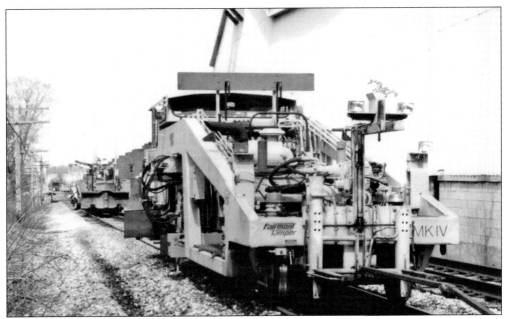

The production tamper (for leveling and aligning track) and ballast regulator (for distributing ballast between ties and sweeping ballast off the tops of ties) are at work on the Bessemer and Lake Erie Railroad at Grove City on May 5, 2005. Ballast (crushed rock placed between and below ties) required attention to support the track under heavy trainloads. (Photograph by Brian C. Sherman.)

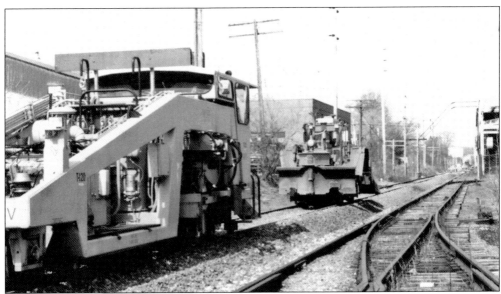

Grove City is the scene for the Bessemer and Lake Erie Railroad production tamper and ballast regulator on May 5, 2005. This was a necessary part of track maintenance to assure ballast was clean, free draining, and free of foreign materials, including vegetation, to achieve a stable track system. (Photograph by Brian C. Sherman.)

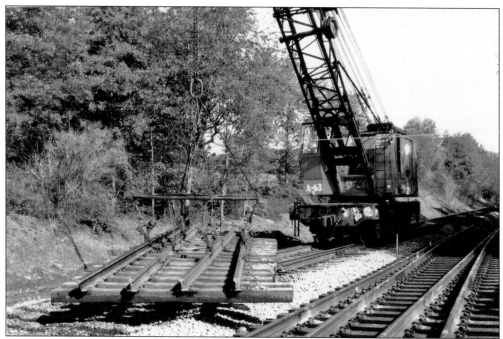

Bessemer and Lake Erie Railroad crane No. A-63 is lifting the old switch panel, which was removed from the track near Grove City during 2006. This was an example of the skills and experience needed to safely handle heavy track sections in a timely manner. (Photograph by Brian C. Sherman.)

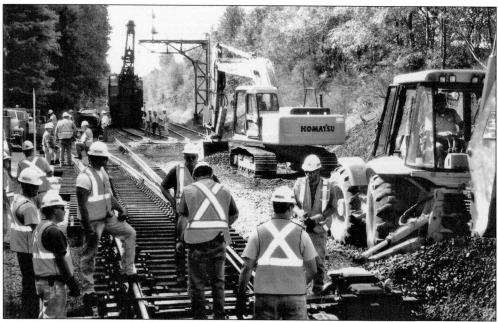

Engineering department employees of the Bessemer and Lake Erie Railroad in their safety vests and hard hats are preparing to install a new switch panel near Grove City during 2006. This job required careful planning and coordination to minimize the time the track was out of service. (Photograph by Brian C. Sherman.)

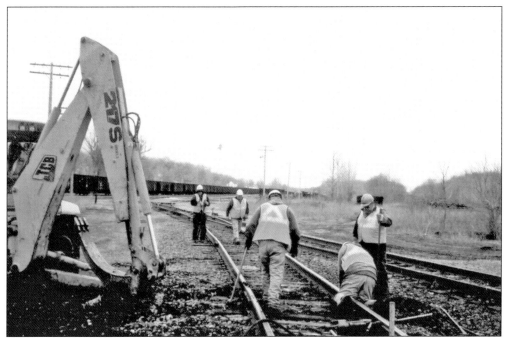

Bessemer and Lake Erie Railroad engineering personnel are replacing ties at the Shenango yard south of Greenville during the spring of 2006. A tie was considered defective if it could not maintain track gauge and track alignment and was not able to distribute the load from rail to the ballast. (Photograph by Brian C. Sherman.)

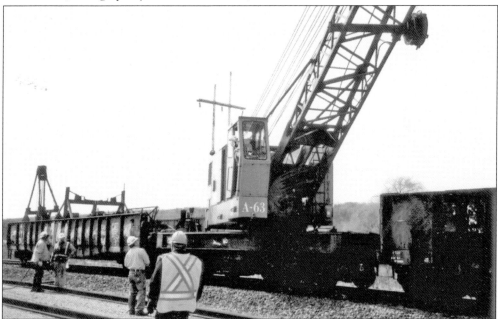

Engineering department personnel are using Bessemer and Lake Erie Railroad locomotive crane No. A-63 as they prepare to lift rail to build a switch panel near Adamsville on April 1, 2005. Working on the railroad required skill and the ability to handle the details of the job. (Photograph by Brian C. Sherman.)

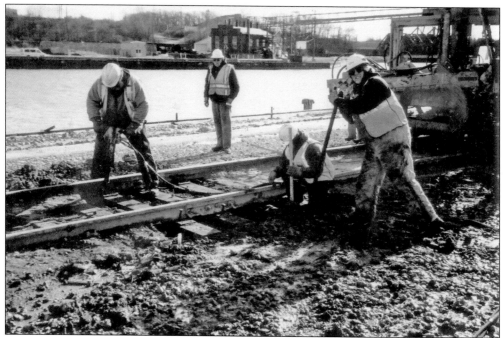

Engineering department employees of the Bessemer and Lake Erie Railroad are replacing ties supporting the track at Conneaut harbor during 2007. With the heavy trains, track requires constant maintenance in all kinds of weather, which even with today's specialized automated machinery requires some hand labor. (Photograph by Brian C. Sherman.)

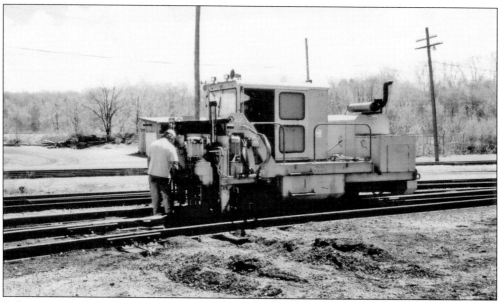

A Bessemer and Lake Erie Railroad track tamper is distributing ballast around and under the ties to give the track proper support at Conneaut harbor on May 5, 2006. Ballast is the crushed rock foundation upon which the ties are set, providing support, stability, and drainage for the track. (Photograph by Brian C. Sherman.)

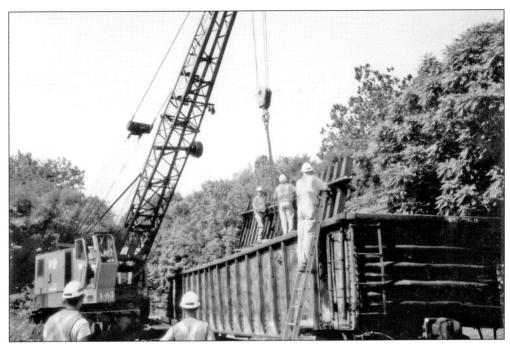

Track maintenance requires close coordination, as evidenced by Bessemer and Lake Erie Railroad engineering department employees unloading a new switch panel with the help of crane No. A-63 near Conneaut during 2006. Over the years, the railroad stressed safety in all of its construction activities. (Photograph by Brian C. Sherman.)

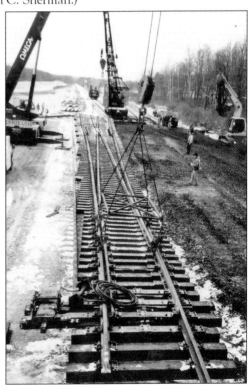

In 2005, preparations are underway to install a new switch on the Kremis-Osgood cutoff near Greenville. The switch was built in advance to reduce the amount of time the track was out of service. This required teamwork, and the railroad was proud of its high efficiency. (Photograph by Brian C. Sherman.)

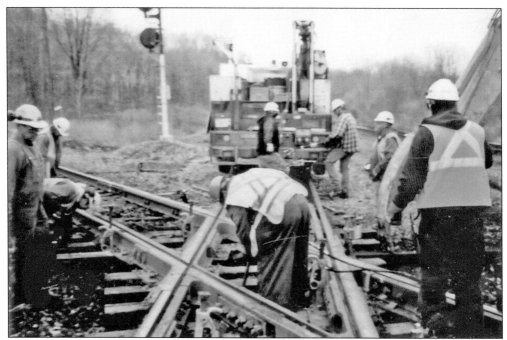

Bessemer and Lake Erie Railroad and Norfolk Southern Railway employees are working together where the two railroads cross. This Norfolk Southern Railway line was the former Erie Lackawanna Railroad from Hoboken, New Jersey, to Chicago. Before the merger of the Erie Railroad with the Delaware, Lackawanna and Western Railroad in 1960, this was the Erie Railroad from Jersey City, New Jersey, to Chicago. (Photograph by Brian C. Sherman.)

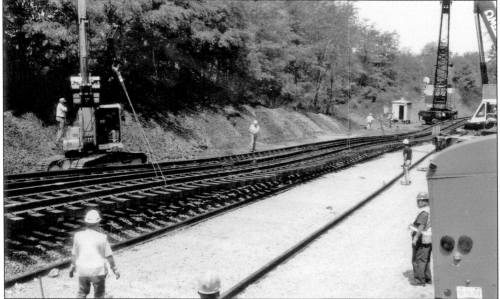

Bessemer and Lake Erie Railroad engineering department employees are preparing to install a new main line switch north of the borough of Grove City during 2006. Careful coordination was needed to position the new switch panel to minimize the time required so that freight service could be resumed as soon as possible. (Photograph by Brian C. Sherman.)

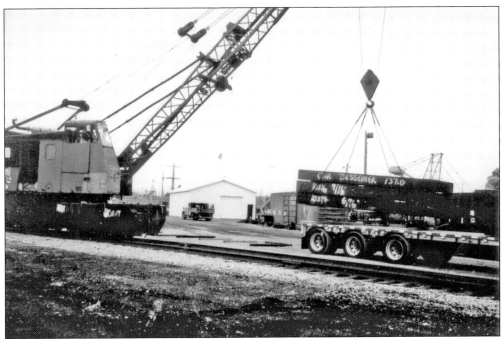

Bridge timbers are being unloaded for replacement on a bridge at Conneaut harbor during 2007. With trains of heavy ore cars, it was important to make sure track and bridges were maintained for rail service, because customers needed delivery of their raw materials without delay. (Photograph by Brian C. Sherman.)

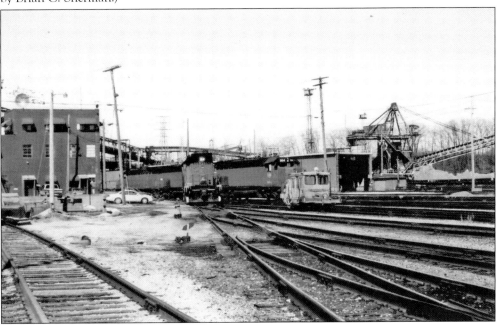

Bessemer and Lake Erie Railroad locomotives No. 904 (type SD40T-3) and No. 868 (type SD38AC) are at Conneaut harbor during 2005. The car inspector used the track car seen near the locomotive. Before the train could leave the harbor, each freight car was inspected before loading to check for any car defects. (Photograph by Brian C. Sherman.)

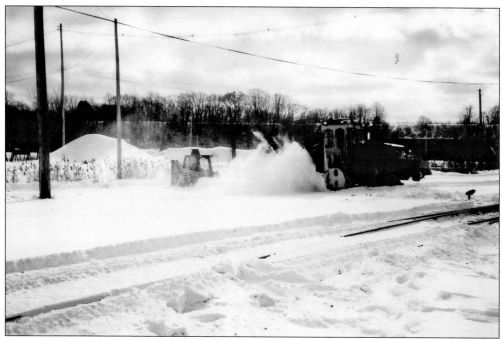

A Bessemer and Lake Erie Railroad ballast regulator and skid-steer loader are working together to remove snow in and around a switch at Conneaut harbor during 2007. Winter snowstorms required careful teamwork to keep the line open, because the railroad's customers depend on the service. (Photograph by Brian C. Sherman.)

A Bessemer and Lake Erie Railroad engineering department employee is using the ballast regulator in snow removal operation at Conneaut harbor during 2007. Crews in the Lake Erie snow belt were ready to keep the line opened during snowstorms as well as handle track maintenance. (Photograph by Brian C. Sherman.)

Two Bessemer and Lake Erie Railroad engineering department employees are removing snow from a switch at Conneaut harbor during 2007. Maintaining a railroad goes on in all kinds of weather. A two-man crew is required, because one person has to watch for train movements. (Photograph by Brian C. Sherman.)

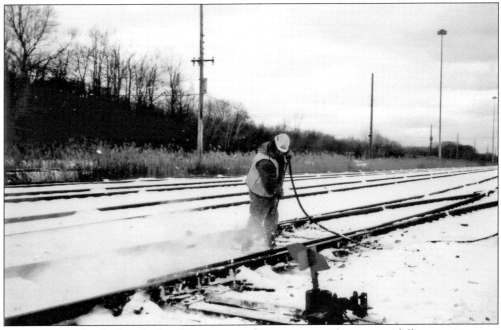

A Bessemer and Lake Erie Railroad engineering department employee is carefully removing snow from a switch using an air compressor at the Conneaut upper coal facility during 2007. Keeping the railroad open in the harsh winter Lake Erie snow belt was never an easy job. (Photograph by Brian C. Sherman.)

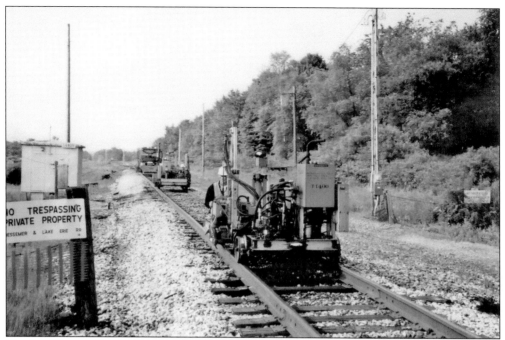

North of Greenville, the Bessemer and Lake Erie Railroad spike puller is pulling spikes from ties to be replaced in 2007. Upon inspection, a tie was replaced when it was broken through, split, rotted, hollow, or deteriorated where a substantial amount of material was decayed. (Photograph by Brian C. Sherman.)

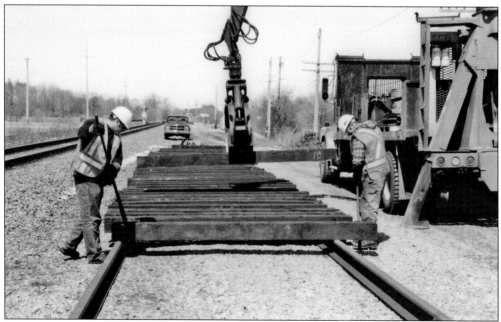

Bessemer and Lake Erie Railroad engineering department personnel are adjusting ties to make a new track panel near the village of Adamsville on April 5, 2005. The new pressure-treated ties were installed perpendicular to the rails at the proper spacing with a tie plate inserted between the tie and rail. (Photograph by Brian C. Sherman.)

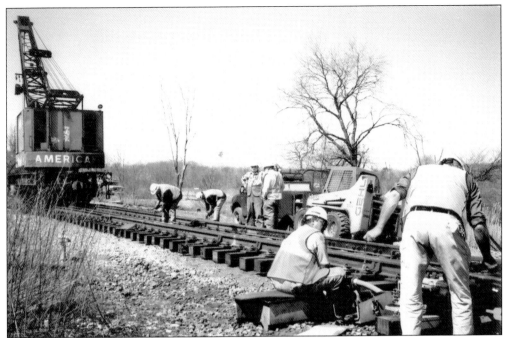

The engineering department and signal department personnel of the Bessemer and Lake Erie Railroad are working together, installing a new switch panel at Kremis, near milepost 80, during 2006 with American locomotive crane No. A-63. This was a job requiring skill, attention to details, and teamwork. (Photograph by Brian C. Sherman.)

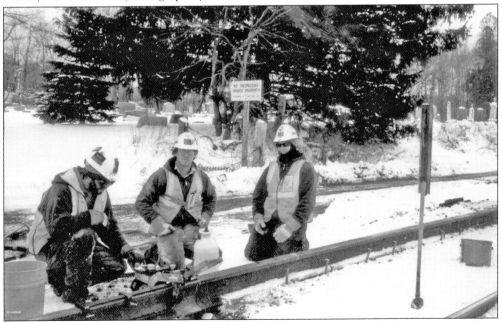

Bessemer and Lake Erie Railroad engineering department employees are preparing to drill the rail and fasten the rails together with joint bars at the village of Hartstown during 2008. The assembly was completed with track bolts, nuts, and lock washers to achieve a tight joint to handle heavy freight cars. (Photograph by Brian C. Sherman.)

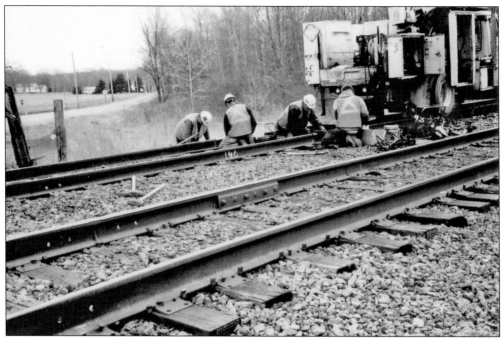

Bessemer and Lake Erie Railroad engineering department personnel are preparing the rail for Thermit welding on the Kremis siding near the village of Kremis during April 2008. Thermit welding is a process used to join rail sections to achieve a smoother ride for freight cars and reduce the number of rail joints subject to wear. (Photograph by Brian C. Sherman.)

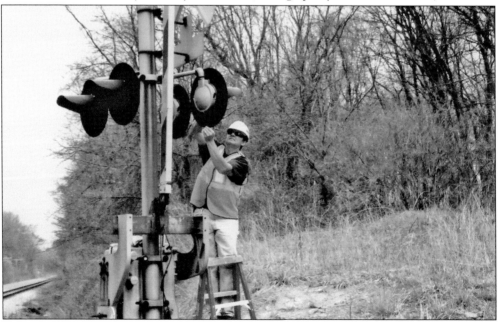

A Bessemer and Lake Erie Railroad signal maintainer is cleaning lenses on Hunts Road east of the borough of Slippery Rock during April 2008. The railroad was noted for its emphasis on safety to prevent accidents, and maintenance of railroad crossing gates was an important part of that program. (Photograph by Brian C. Sherman.)

Four

STEAM TO DIESEL LOCOMOTIVE OPERATION

The Shenango and Allegheny Railroad purchased two American-type locomotives with a 4-4-0 wheel arrangement from Danforth Locomotive and Machine Company during 1869. Six Mogul-type locomotives with a 2-6-0 wheel arrangement were purchased from Pittsburgh Locomotive Works by the Pittsburgh, Shenango and Lake Erie Railroad in 1891 and 1892. Seven locomotives with a 4-6-0 wheel arrangement were purchased from Pittsburgh Locomotive Works during the period 1893 to 1895. Next came Consolidation-type locomotives with a 2-8-0 wheel arrangement followed in 1916 by Santa Fe–type locomotives with a 2-10-2 wheel arrangement. In 1929, Baldwin Locomotive Works designed a Texas-type steam locomotive with a 2-10-4 wheel arrangement that performed well, but ultimately diesels would prove to be very efficient. Westinghouse built the Bessemer and Lake Erie Railroad's first diesel, No. 281 rated at 530 horsepower, in 1936. The second diesel locomotive, No. 282, was a 1,000-horsepower switcher built by Baldwin Locomotive Works in 1949. Individual diesel units could be combined to achieve increased hauling capacity without requiring axle loadings of a large steam locomotive. This resulted in a reduction in rail weight from 155 pounds per yard to 140 pounds per yard. By 1953, the railroad had completely dieselized with 75 units of which 54 were 1,500-horsepower road units type F-7 built by the Electro-Motive Division of General Motors Corporation (Nos. 701A to 728A and 701B to 726B). The Electro-Motive Division of General Motors supplied 7 type SD-18, 1,800-horsepower diesels (Nos. 851 to 857) in 1963, 3 type SD38, 2,000-horsepower diesels (Nos. 861 to 863) in 1967, 6 type SD38AC, 2,000-horsepower diesels (Nos. 864 to 869) in 1971, and 13 type SD38-2, 2,000-horsepower diesels (Nos. 870 to 879 and 890 to 892) during 1973 to 1976. A new generation of model SD40T-3 diesels, numbered 900 to 910, went into service with units No. 900, No. 901, and No. 902 handling their first freight run from Kremis to North Bessemer on January 5, 2000. The *T* in the model designation stood for "tunnel," owing to the modified hoods intended to remedy cooling problems in tunnel environments. In June 2008, the locomotives are still in the traditional Bessemer and Lake Erie Railroad orange and black paint scheme.

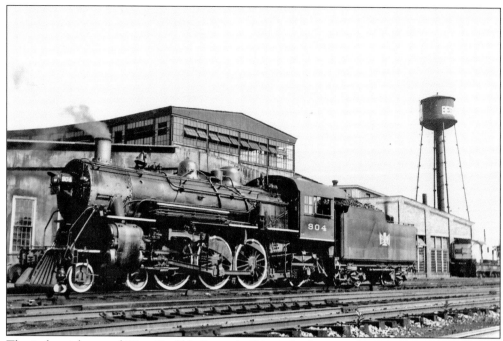

The industrial area of West Twelfth Street in Erie is the location for Bessemer and Lake Erie Railroad steam locomotive No. 904 with locomotive crane No. A51 on the right-hand side of the picture in 1936. No. 904 was one of four Pacific-type steam locomotives assigned to passenger service. Locomotive crane No. A51 had a capacity of 200 tons. (Greenville Railroad Park collection.)

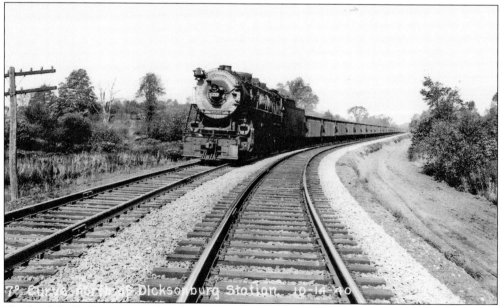

North of the Dicksonburg railroad station, Bessemer and Lake Erie Railroad steam locomotive No. 607 is heading a train of hopper cars on October 14, 1940. Over the years, improvements in locomotives, rolling stock, and track resulted in the average load per freight car increasing from 52.8 tons in 1929 to 73.6 tons by 1942. (Marty Magdich collection.)

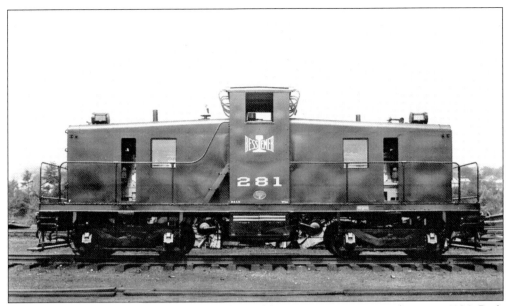

The first Bessemer and Lake Erie Railroad diesel locomotive, No. 281, is shown in 1936. Built by Westinghouse in 1936, the 530-horsepower unit weighed 143,500 pounds. It was assigned to handle switching of cars in the Erie yard and was the only diesel on the property until the second unit was purchased during 1949. (Ernest W. Casbohm collection.)

Pittsburgh office personnel at the Greenville shops for the September 20, 1950, tour are, from left to right, (first row) J. Clark, M. Dufresne, T. Anderson, J. Richards, F. Becer, and W. Schwartz; (second row) C. North, E. Green, C. Hoover, L. Junk, M. McAndrew, C. Rosenbauer, K. Flohr, E. Cotten, M. McCloskey, D. Grimm, R. Vernon, and V. Fisher; (third row) F. Zinke, D. Brooks, F. Love, F. Gothe, J. Gallagher, J. Hodgkiss, R. Gigler, T. Durkin, F. Kenyon, and J. Carey. (Ernest W. Casbohm collection.)

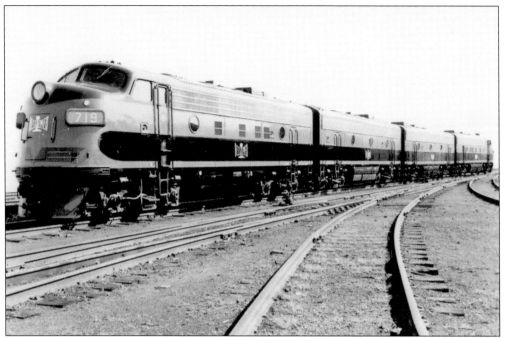

Basking in the sunshine, Bessemer and Lake Erie Railroad locomotive No. 719, built by the Electro-Motive Division of General Motors Corporation in June 1952, is at the Albion yard in September 1952. This 1,500-horsepower diesel unit weighed 247,000 pounds and had a tractive effort of 40,000 pounds. (Ernest W. Casbohm collection.)

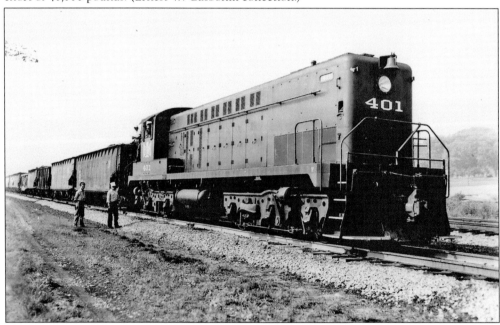

Bessemer and Lake Erie Railroad diesel switcher No. 401, built by Baldwin Locomotive Works in 1949, with a train of hopper cars is in yard service. Weighing 325,000 pounds, the 1,500-horsepower locomotive had a tractive effort of 42,800 pounds. It was later sold to the Elgin, Joliet and Eastern Railway. (Marty Magdich collection.)

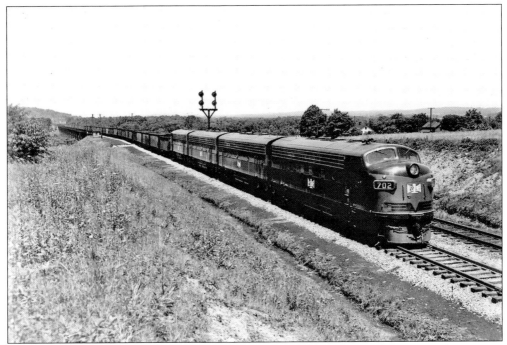

The Bessemer and Lake Erie Railroad four-unit diesel headed by No. 702 operates as one locomotive of 6,000 horsepower. Built by the Electro-Motive Division of General Motors Corporation in 1950, these diesels were painted an attractive orange and black with the Bessemer emblem in white on the front and side of the locomotive. (Greenville Railroad Park collection.)

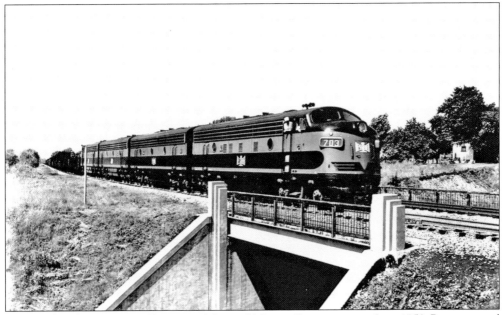

Built by the Electro-Motive Division of General Motors Corporation in June 1950, Bessemer and Lake Erie Railroad type F-7 locomotive No. 703 heads a train powered by four diesel units with a total weight of 496 tons. This locomotive was sold to the Baltimore and Ohio Railroad in 1962. (Marty Magdich collection.)

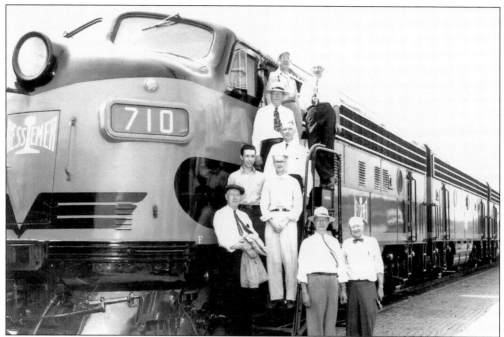

Bessemer and Lake Erie Railroad type F-7 diesel No. 710, delivered by the Electro-Motive Division of General Motors Corporation in March 1951, is on an inspection trip. This 1,500-horsepower diesel unit with a tractive effort of 40,000 pounds was sold to the Baltimore and Ohio Railroad during 1962. (Marty Magdich collection.)

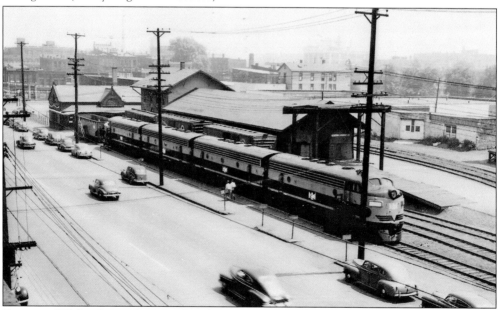

Four type F-7 diesel units built by the Electro-Motive Division of General Motors Corporation, each rated 1,500 horsepower, are at the Erie terminus on West Twelfth Street west of Peach Street. The Bessemer and Lake Erie Railroad passenger station is just beyond the last diesel unit. The railroad track and associated buildings were later removed from this site. (Marty Magdich collection.)

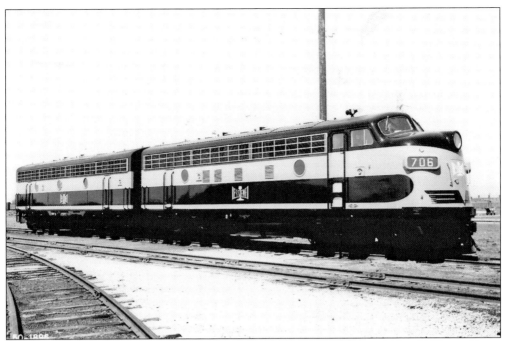

Bessemer and Lake Erie Railroad type F-7 diesel units No. 706A and No. 706B sparkle in the sunshine after delivery during 1950 from the Electro-Motive Division of General Motors Corporation. The A unit was the lead unit. The B unit was the booster unit. These units were sold to the Baltimore and Ohio Railroad during 1962. (Greenville Railroad Park collection.)

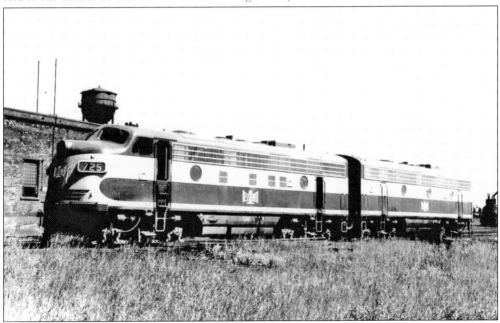

Type F-7 diesel units No. 725A and No. 725B, built by the Electro-Motive Division of General Motors Corporation in February 1953, are awaiting the next assignment. There were 54 type F-7 diesel units, each rated 1,500 horsepower on the railroad. More powerful diesel units later replaced these units. (Greenville Railroad Park collection.)

The new Bessemer and Lake Erie Railroad diesel shop at Conneaut harbor is ready for use on January 21, 1952. Workrooms, an office, and locker rooms for maintenance of equipment were on the ground floor. The second floor contained workrooms and locker rooms for the yard crews plus a conference room. The yardmaster's office on the third floor had a clear view of the entire yard. (Ernest W. Casbohm collection.)

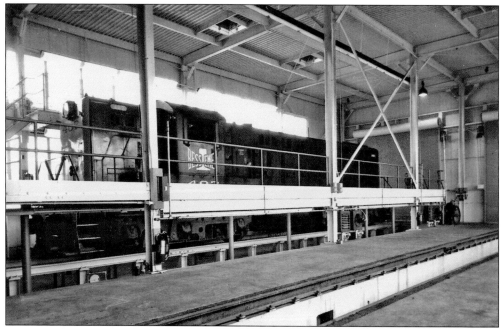

Bessemer and Lake Erie Railroad diesel switcher No. 407 is in the Conneaut diesel shop during 1952. The March 1952 *Bessemer Bulletin* regarding diesel locomotive maintenance notes, "The operation of the shop is geared to the thorough testing and periodic maintenance of one locomotive each Sunday, when dock operations permit at least one locomotive to be relieved from service." (Ernest W. Casbohm collection.)

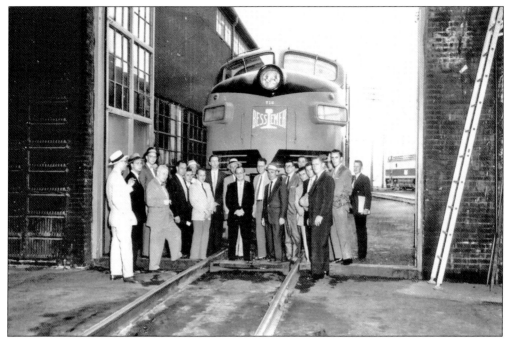

An inspection tour is taking place on the Bessemer and Lake Erie Railroad. The January 1952 *Bessemer Bulletin* notes, for diesel locomotives, "The service life of the diesel engine as well as the electrical and air brake equipment, is dependent upon freedom from dirt and dust in the air, the fuel oil, and the lubricating oil. Also cleanliness is imperative to prevent fires." (Marty Magdich collection.)

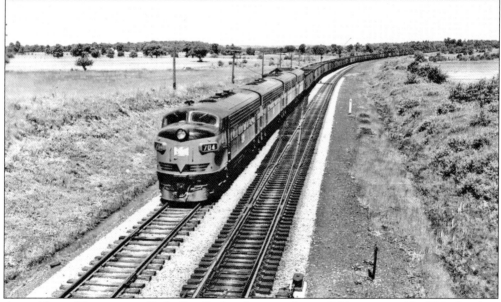

A northbound Bessemer and Lake Erie Railroad train with type F-7 locomotive No. 704 is heading four diesel units on a well-maintained right-of-way through the borough of Springboro. The locomotive, built by the Electro-Motive Division of General Motors Corporation in June 1950, was sold to the Baltimore and Ohio Railroad during 1962. (Ernest W. Casbohm collection.)

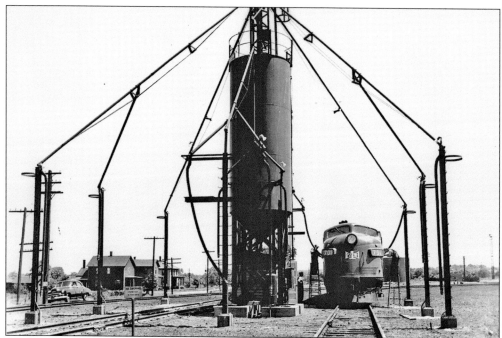

Locomotive No. 701 is at the new sand and fuel facility at Albion. With conversion to diesel operation, the September 1953 *Bessemer Bulletin* notes, "One thing that the diesel will never replace, however, is the fascination that a steam engine, with a tonnage train, whistle blowing and smoke exhausting into the atmosphere, has had over past generations of small boys and grownups too." (Ernest W. Casbohm collection.)

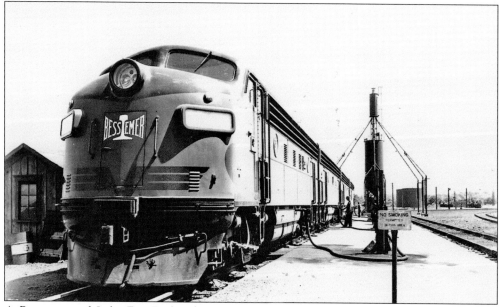

A Bessemer and Lake Erie Railroad type F-7 diesel locomotive is being refueled at Albion. The September 1953 *Bessemer Bulletin* notes that by August 24, 1953, the railroad only had 33 steam locomotives of various types on the property. The diesel locomotive was replacing steam locomotives on most railroads in the United States. (Ernest W. Casbohm collection.)

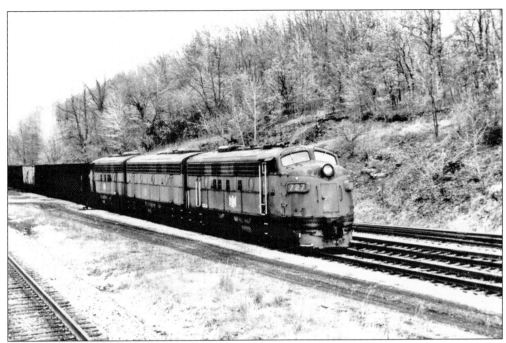

Three Bessemer and Lake Erie Railroad type F-7 diesel units headed by No. 727 are at Queen Junction (milepost 43), where the former Western Allegheny Division connected to the main line. The Electro-Motive Division of General Motors Corporation built this locomotive during February 1953. Each of these units was rated at 1,500 horsepower and weighed 247,000 pounds. (Photograph by Marty Magdich.)

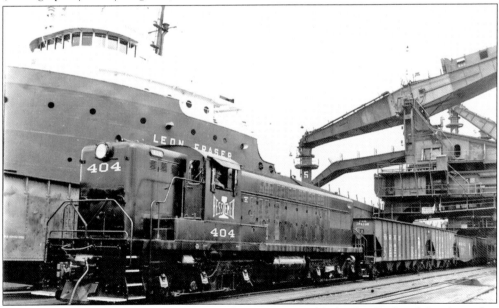

Conneaut harbor around 1950 is the scene for Bessemer and Lake Erie Railroad diesel switcher No. 404 alongside the ore boat *Leon Fraser*. The ore boat was 640 feet long and 67 feet wide and had a rated capacity of 18,600 long tons in 24 feet of water. The locomotive was 58 feet long and weighed 165 tons. (Ernest W. Casbohm collection.)

Looking north, a New York Central Railroad freight train is westbound over the Bessemer and Lake Erie Railroad original main line at Osgood on May 29, 1964. The Kremis-Osgood cutoff line was east of this view (off from the right-hand side of the picture) and bypassed Greenville with a reduced southward grade and saved 3.13 miles. (Photograph by Kenneth C. Springirth.)

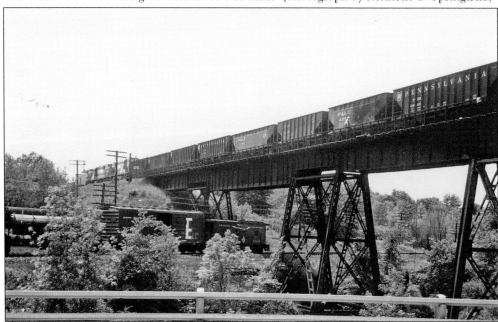

A southbound Bessemer and Lake Erie Railroad freight train is on the Kremis-Osgood cutoff using the high-level bridge over an eastbound Erie Lackawanna Railroad freight train at Osgood on May 29, 1964. This cutoff was placed in service in May 1902 and reduced the southbound grade from 1.3 percent to 0.6 percent. (Photograph by Kenneth C. Springirth.)

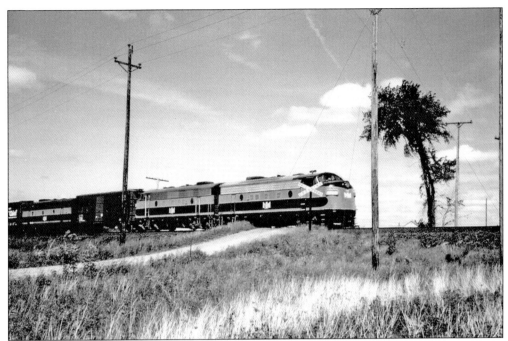

Just north of the borough of Albion and south of the borough of Platea, a Bessemer and Lake Erie Railroad freight train powered by type F-7 diesel units is southbound on the Erie branch crossing Bowmantown Road on May 29, 1964. Higher horsepower locomotives later replaced these 1,500-horsepower diesel units. (Photograph by Kenneth C. Springirth.)

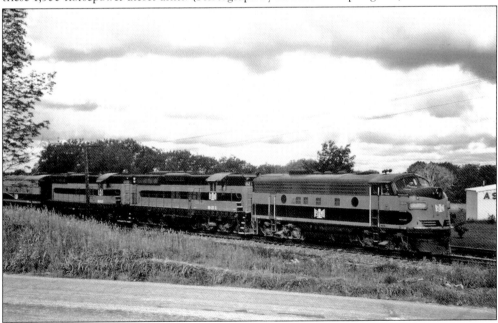

A southbound Bessemer and Lake Erie Railroad train is about to cross South Main Street in Albion on May 29, 1964. A type F-7 locomotive, a type SD-9 locomotive (No. 821), and a type SD-7 locomotive (No. 803) headed the train. This variety of diesel locomotives made the railroad a photographic paradise. (Photograph by Kenneth C. Springirth.)

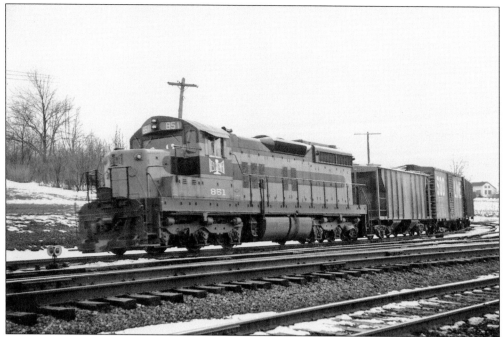

With traces of snow on the ground on February 22, 1964, Bessemer and Lake Erie Railroad diesel No. 851 is at Wallace Junction, which is the interchange point with the Nickel Plate Road. The Electro-Motive Division of General Motors Corporation built this 1,800-horsepower type SD-18 locomotive in January 1963. (Photograph by Kenneth C. Springirth.)

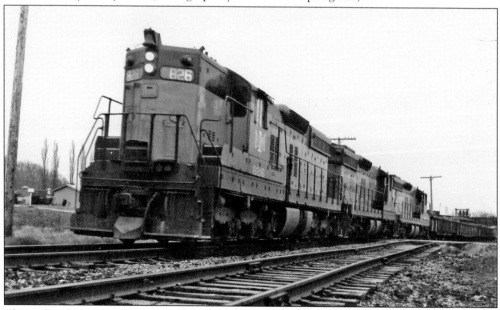

Three diesel locomotives are at Wallace Junction on March 9, 1964. The lead locomotive, No. 826, was type SD-9, rated 1,750 horsepower, and built by the Electro-Motive Division of General Motors Corporation in March 1956 as No. 101 for the Duluth, Missabe and Iron Range Railway. The Bessemer and Lake Erie Railroad acquired it during 1965. (Photograph by Kenneth C. Springirth.)

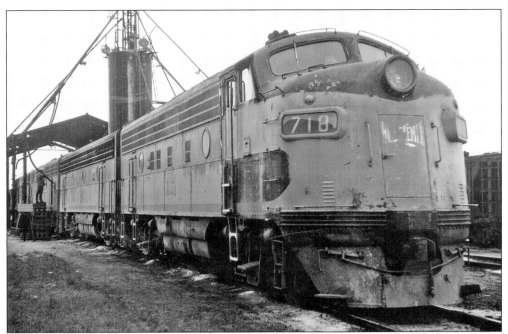

On May 26, 1973, Bessemer and Lake Erie Railroad type F-7 locomotive No. 718 is at the Albion yard for service with other diesel units. Built by the Electro-Motive Division of General Motors Corporation in June 1952, this 1,500-horsepower locomotive had been in service almost 21 years when this picture was taken. (Photograph by Kenneth C. Springirth.)

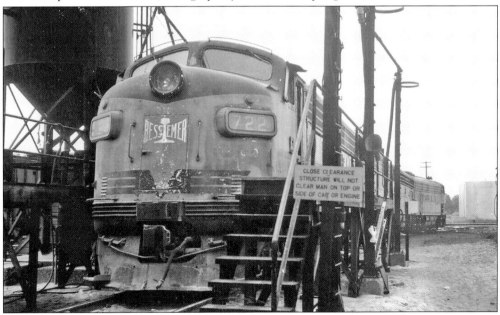

No. 722, a type F-7 diesel unit, is in a line of diesel units at the Albion yard on May 26, 1973. This Bessemer and Lake Erie Railroad locomotive was one of 10 units numbered 715A to 724A and 8 units numbered 715B to 722B built by the Electro-Motive Division of General Motors Corporation during June 1952, each rated 1,500 horsepower. (Photograph by Kenneth C. Springirth.)

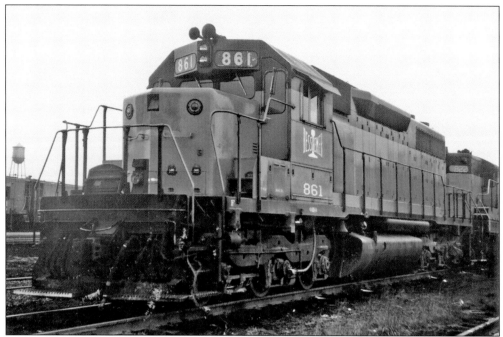

In the lineup for the next assignment, Bessemer and Lake Erie Railroad diesel unit No. 861, in its traditional orange and black paint scheme, is at the Albion yard on May 26, 1973. The Electro-Motive Division of General Motors Corporation built this six-axle, 2,000-horsepower type SD38 locomotive during 1967. (Photograph by Kenneth C. Springirth.)

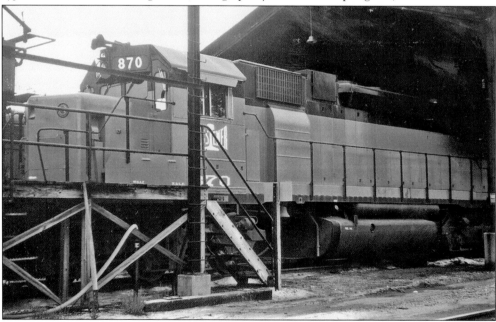

Bessemer and Lake Erie Railroad locomotive No. 870 is at the Albion yard on May 26, 1973. This 2,000-horsepower type SD38-2 diesel unit was built by the Electro-Motive Division of General Motors Corporation during 1973 as an updated SD38 with modular electronic control systems. (Photograph by Kenneth C. Springirth.)

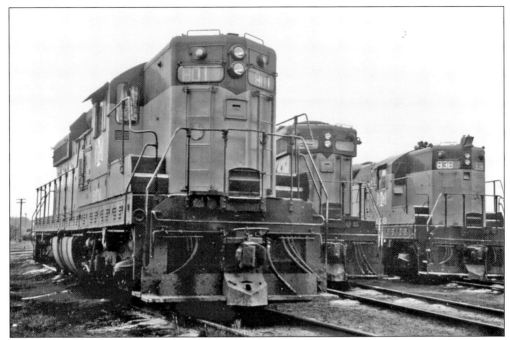

The Albion yard is the scene for three Bessemer and Lake Erie Railroad diesel units on May 26, 1973. These locomotives from the Electro-Motive Division of General Motors Corporation are, from left to right, No. 801 (type SD-7, rated 1,500 horsepower and built in October 1952 for passenger service), No. 821 (type SD-9, built in February 1958), and No. 838 (type SD-9, rated 1,750 horsepower and built in 1971). (Photograph by Kenneth C. Springirth.)

Bessemer and Lake Erie Railroad locomotive No. 823 is heading a southbound train ready to pick up a message before crossing South Main Street in Albion on March 27, 1970. This type SD-9 diesel unit rated 1,750 horsepower, built by the Electro-Motive Division of General Motors Corporation in February 1958 for the Duluth, Missabe and Iron Range Railway, was acquired during 1964. (Photograph by Kenneth C. Springirth.)

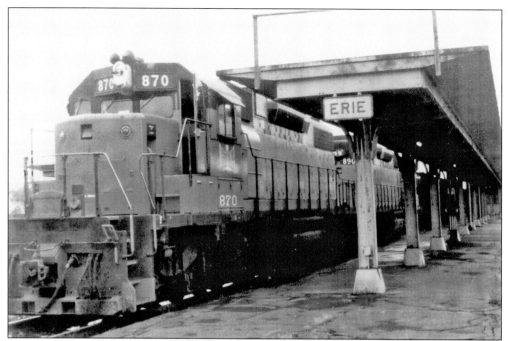

At the union passenger station in Erie, Bessemer and Lake Erie Railroad type SD38-2 locomotives No. 870 and No. 890 are powering a freight train. The Electro-Motive Division of General Motors Corporation built No. 870 during 1973 and No. 890 during 1975. These were 2,000-horsepower, six-axle diesel locomotives each weighing 368,000 pounds. (Ernest W. Casbohm collection.)

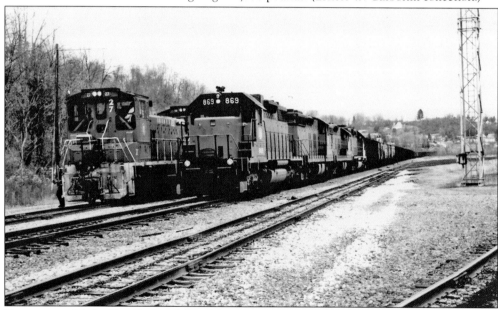

Bessemer and Lake Erie Railroad diesel No. 869 with Union Railroad diesel switcher No. 27 on the left is at the north end of the Union Railroad yard at North Bessemer. This was one of six type SD38AC diesels numbered 864 to 869 built by the Electro-Motive Division of General Motors Corporation during 1971. Locomotive No. 864 was off the roster by the mid-1970s. (Photograph by Marty Magdich.)

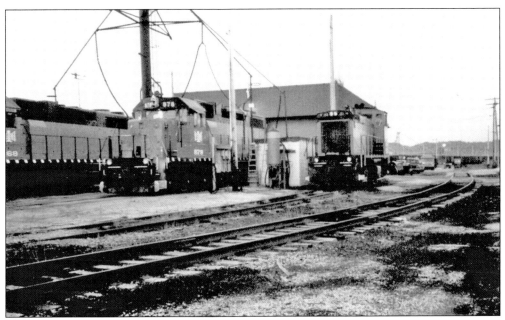

On June 22, 2003, Bessemer and Lake Erie Railroad locomotives are awaiting assignment at Conneaut harbor. Produced by the Electro-Motive Division of General Motors Corporation, the locomotives here are, from left to right, No. 868 (type SD38AC, rated 2,000 horsepower and built in 1971), No. 878 (type SD38-2, rated 2,000 horsepower and built in 1973), and No. 155 (switcher, rated 1,500 horsepower). (Photograph by Brian C. Sherman.)

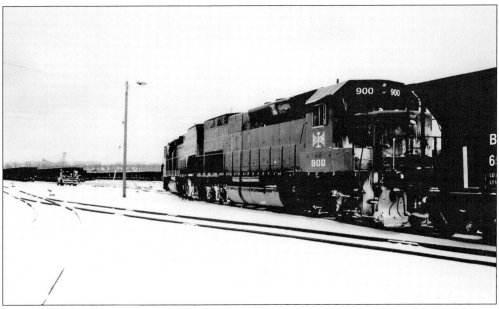

A string of empty hopper cars is heading northward into Conneaut harbor with the end Bessemer and Lake Erie Railroad diesel unit No. 900 showing snow covering portions of the end of the locomotive. This was originally St. Louis Southwestern Railway locomotive No. 9289, built in February 1973. (Photograph by Brian C. Sherman.)

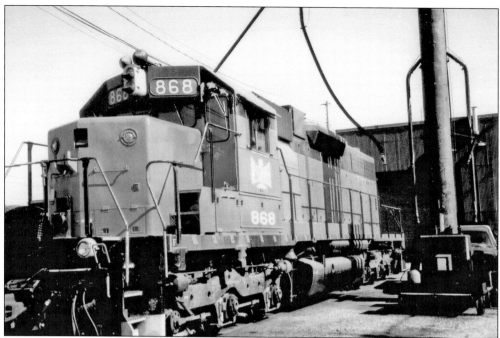

Conneaut harbor on June 18, 2004, finds Bessemer and Lake Erie Railroad locomotive No. 868 ready for duty. This 2,000-horsepower type SD38AC locomotive was equipped with a model AR10 alternating current alternator in place of the direct current generator that was used on type SD38 diesel locomotives. (Photograph by Brian C. Sherman.)

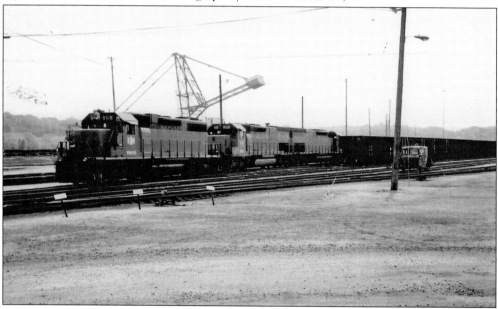

A northbound train of empty hopper cars is coming into Conneaut harbor during 2006, headed by type SD38AC locomotive No. 868. Between June and October 1971, the Electro-Motive Division of General Motors Corporation built six of these units for the Bessemer and Lake Erie Railroad, eight for the Duluth, Missabe and Iron Range Railway, and one for BC Hydro. (Photograph by Brian C. Sherman.)

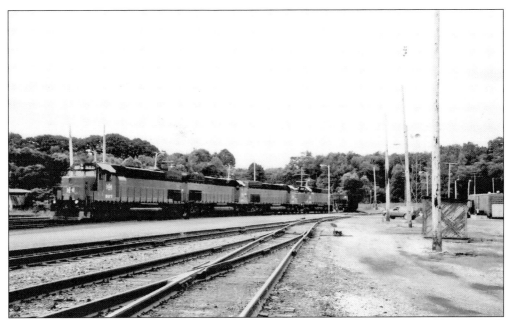

On August 5, 2005, Bessemer and Lake Erie Railroad locomotive No. 907 is heading north with a train of empty hopper cars for Conneaut harbor. This type SD40T-3 locomotive had the air intake grills at the lower rear of the locomotive's long hood so the engine could receive cool and clean air into the radiator section. (Photograph by Brian C. Sherman.)

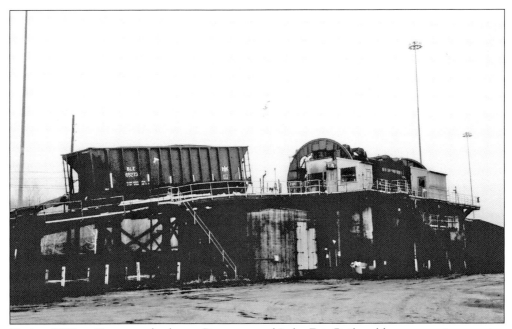

During 2007 at Conneaut harbor, a Bessemer and Lake Erie Railroad hopper car is preparing to enter the rotary car dumper, which turns the car upside down to unload coal. Northbound coal trains were once an important source of traffic for the railroad. (Photograph by Brian C. Sherman.)

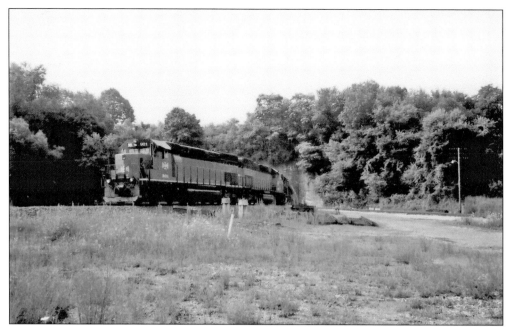

A northbound train headed by Bessemer and Lake Erie Railroad type SD40T-3 locomotive No. 901 (originally built in May 1972 as Southern Pacific Railroad locomotive No. 9232) is coming into Conneaut during the summer of 2007. Boise Locomotive Works rebuilt locomotives numbered 900 to 906. The Duluth, Missabe and Iron Range Railway rebuilt locomotives numbered 907 to 910. (Photograph by Brian C. Sherman.)

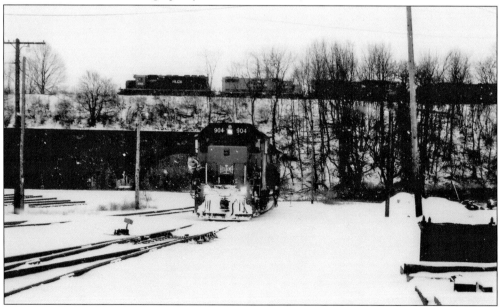

Bessemer and Lake Erie Railroad type SD40T-3 locomotive No. 904 (originally built as St. Louis Southwestern Railway locomotive No. 9269 in 1973) is heading north toward Conneaut harbor passing under an eastbound CSX Railroad train in January 2006. The brakeman on the locomotive was ready to throw the switch to position the train in the railroad yard. (Photograph by Brian C. Sherman.)

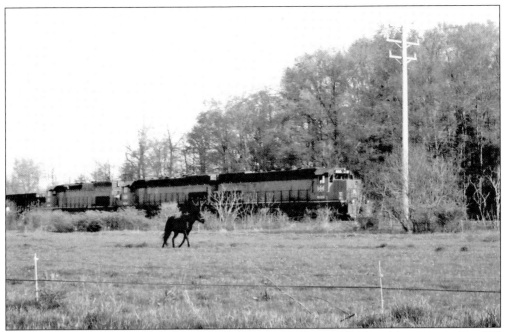

With a horse in the adjacent pasture, Bessemer and Lake Erie Railroad locomotive No. 905 (originally St. Louis Southwestern Railway No. 9286, built during 1973) is pulling a northbound train for Conneaut as it approaches Lexington Road during 2007. Locomotives numbered 900 to 910 weighed 410,000 pounds, making them the heaviest diesel locomotives owned by this railroad. (Photograph by Brian C. Sherman.)

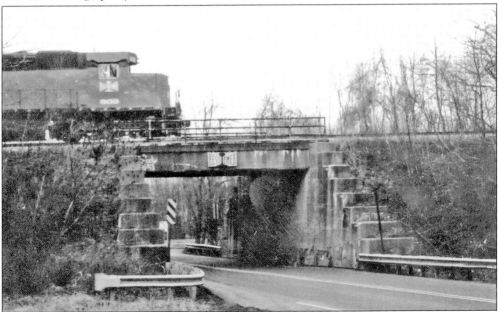

A southbound Bessemer and Lake Erie Railroad train powered by type SD40T-3 locomotive No. 908 (originally St. Louis Southwestern Railway No. 9301, built in 1973) is crossing the bridge over United States Highway 6N in West Springfield, about three miles east of the Ohio state line, in the spring of 2007. (Photograph by Brian C. Sherman.)

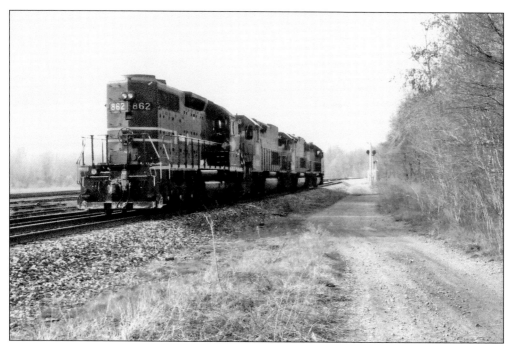

Four locomotives, No. 862 (type SD38 in a mainly Duluth, Missabe and Iron Range Railway paint scheme), No. 902 (type SD40T-3), No. 867 (type SD38AC), and No. 908 (type SD40T-3), are at the location where the Conneaut and Erie branches of the Bessemer and Lake Erie Railroad meet in the borough of Cranesville. (Photograph by Brian C. Sherman.)

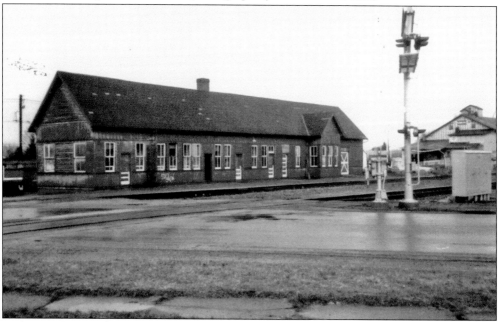

In this 1985 scene, the former Bessemer and Lake Erie Railroad passenger station on Pearl Street in Albion is serving the railroad's engineering department and used for general purposes. This station was later torn down. The feed mill on the right-hand side of the picture was still in place in July 2008. (Photograph by Brian C. Sherman.)

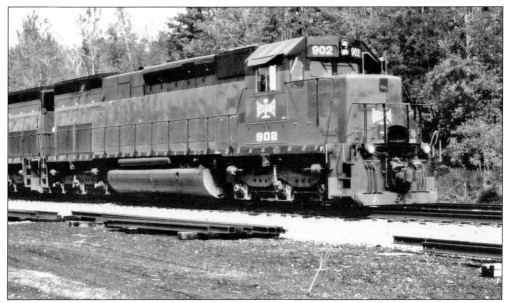

A southbound ore train powered by Bessemer and Lake Erie Railroad six-axle, 3,000-horsepower, type SD40T-3 locomotive No. 902 (originally Southern Pacific Railroad No. 9189, built in March 1972) is at Pearl Street in Albion on May 24, 2008. This rebuilt locomotive featured a new computer system to improve tractive effort, which is the ability to move trailing freight tonnage. (Photograph by Brian C. Sherman.)

In the late afternoon of April 14, 2004, Bessemer and Lake Erie Railroad type SD40T-3 locomotive No. 905 is ready to cross Pearl Street in Albion on a northbound run to Conneaut. The *T* in the designation denoted "tunnel," which featured lower radiator air intake to handle cooling problems in tunnel environments. (Photograph by Brian C. Sherman.)

Southbound Bessemer and Lake Erie Railroad type SD40T-3 locomotive No. 900 is crossing State Street in the borough of Albion during 2007. This locomotive, rebuilt during 1999, featured lowered radiator air intakes and new electronics to improve reliability. The former Albion yard was north of this crossing. (Photograph by Brian C. Sherman.)

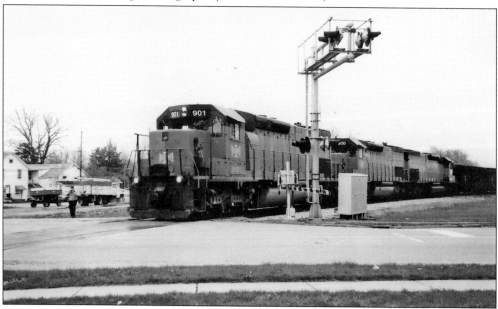

The Pearl Street crossing in Albion is the location for Bessemer and Lake Erie Railroad type SD40T-3 locomotives No. 901, No. 900, and No. 908, southbound on April 19, 2008, at 4:45 p.m. Southern Pacific Railroad and Electro-Motive Division of General Motors Corporation engineers developed these tunnel-type locomotives that allowed cooler air to be drawn from an area just above the locomotive running boards. (Photograph by Brian C. Sherman.)

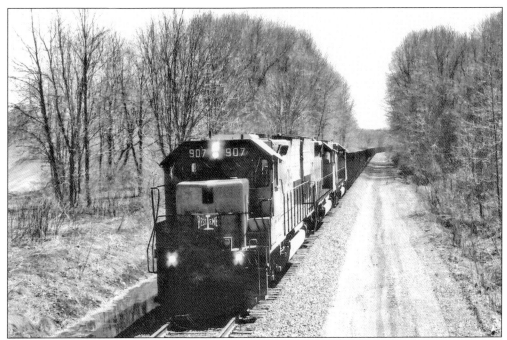

A northbound coal train is approaching the Fish Road crossing south of the borough of Conneautville on March 30, 2005, headed by Bessemer and Lake Erie Railroad 3,000-horsepower type SD40T-3 locomotive No. 907. The Electro-Motive Division of General Motors Corporation built this as No. 9305 for the Southern Pacific Railroad in September 1973. (Photograph by Brian C. Sherman.)

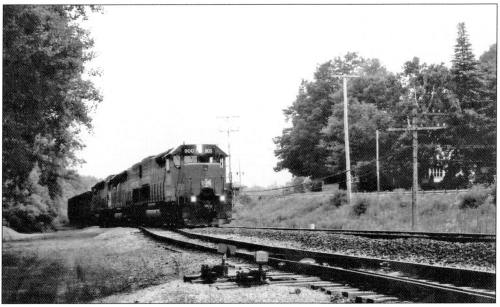

Mulberry Street in Conneautville is the scene for this southbound Bessemer and Lake Erie Railroad train headed by type SD40T-3 locomotive No. 900 at the Conneautville siding during 2005. This was one of 11 rebuilt locomotives numbered 900 to 910 received during 1999 featuring fully insulated and sound-deadened cabs. (Photograph by Brian C. Sherman.)

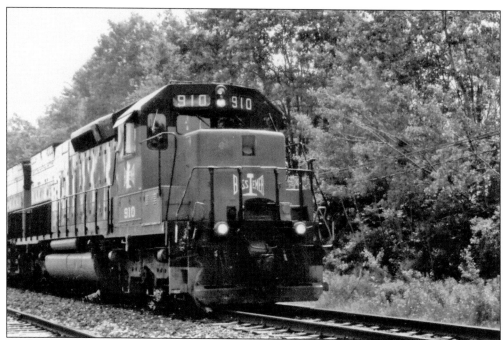

Meadville Junction near Conneaut Lake is the scene for a southbound train powered by Bessemer and Lake Erie Railroad type SD40T-3 locomotive No. 910 on the siding waiting for the arrival of the northbound train on the main track during 2006. Electro-Motive Division of General Motors Corporation originally built this locomotive as No. 9229 for the Southern Pacific Railroad in May 1972. (Photograph by Brian C. Sherman.)

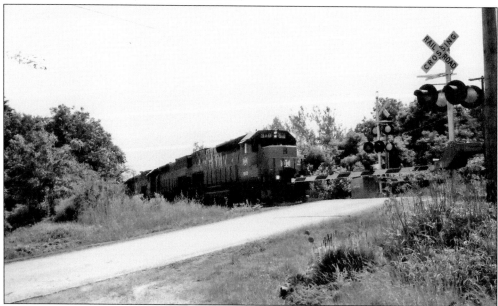

The Keepville crossing south of Albion, which is actually Carter Road, is the scene for Bessemer and Lake Erie Railroad locomotive No. 910, leading a southbound run during 2007. This was one of 11 extensively rebuilt locomotives numbered 900 to 910 purchased for the railroad during 1999. (Photograph by Brian C. Sherman.)

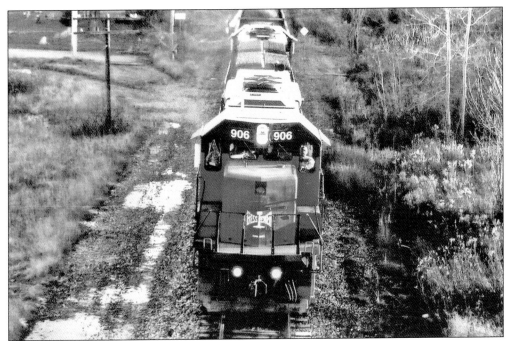

A northbound Bessemer and Lake Erie Railroad coal train headed by 3,000-horsepower type SD40T-3 locomotive No. 906 for the Conneaut harbor is crossing under the bridge for United States Highway 322 at the village of Hartstown during 2005. This locomotive was built by the Electro-Motive Division of General Motors Corporation as Southern Pacific Railroad No. 9348 during 1974. (Photograph by Brian C. Sherman.)

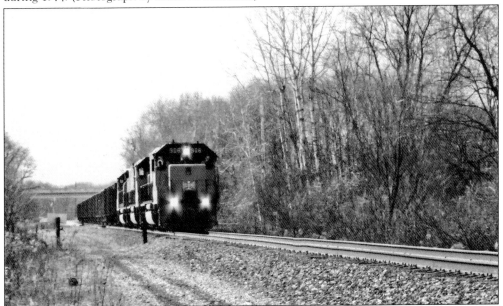

West of Conneaut Lake, a northbound train of empty hopper cars powered by Bessemer and Lake Erie Railroad locomotive No. 908 has crossed under the Shermansville bridge for United States Highway 6. Three of these type SD40T-3 locomotives handled the work of four older diesel units in road service. (Photograph by Brian C. Sherman.)

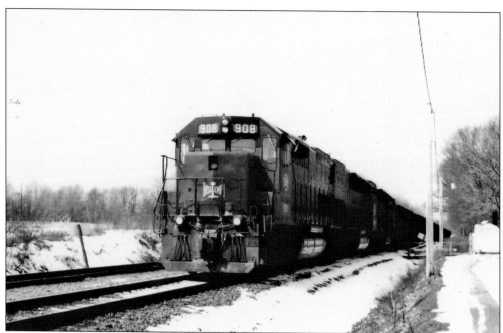

The winter of 2005 finds Bessemer and Lake Erie Railroad type SD40T-3 locomotive No. 908 leading a train on the Kremis siding near the village of Kremis and waiting for permission to proceed south. This was one of 11 extensively rebuilt locomotives numbered 900 to 910 purchased during 1999, featuring a 33 percent increase in tractive effort, which is the ability to move trailing freight tonnage. (Photograph by Brian C. Sherman.)

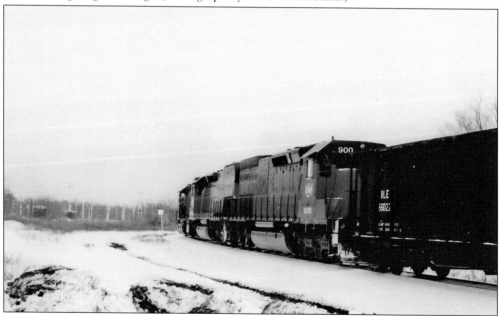

In the winter of 2007, Bessemer and Lake Erie Railroad locomotives with No. 900 in the rear are northbound for Conneaut having just crossed Pearl Street in Albion. Winter snow is dramatically heavier on the northern part of the railroad along Lake Erie than at the railroad's southern terminus of North Bessemer. (Photograph by Brian C. Sherman.)

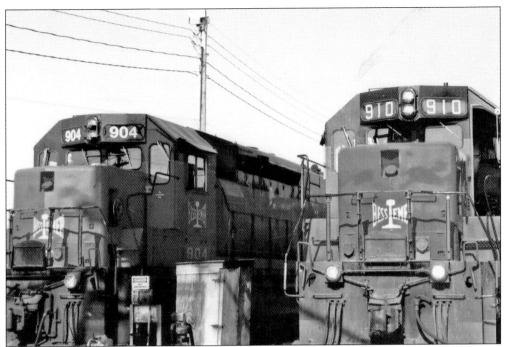

Two Bessemer and Lake Erie Railroad type SD40T-3 locomotives, No. 904 and No. 910, are awaiting the next assignment at the Greenville shops. The Electro-Motive Division of General Motors Corporation originally built these diesel units, and they were extensively rebuilt during 1999 before being placed into service. (Photograph by Brian C. Sherman.)

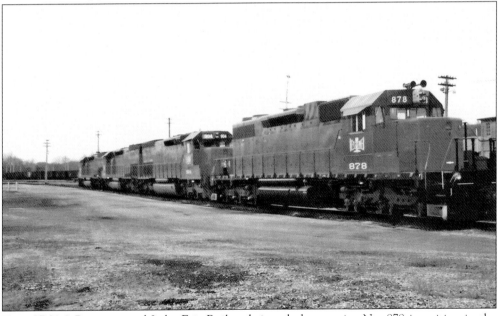

Type SD38-2 Bessemer and Lake Erie Railroad six-axle locomotive No. 878 is waiting in the lineup for the next assignment at the Greenville shops during 2006. The Electro-Motive Division of General Motors Corporation built this 2,000-horsepower diesel during 1973. This locomotive was 68.833 feet long and 10.26 feet wide. (Photograph by Brian C. Sherman.)

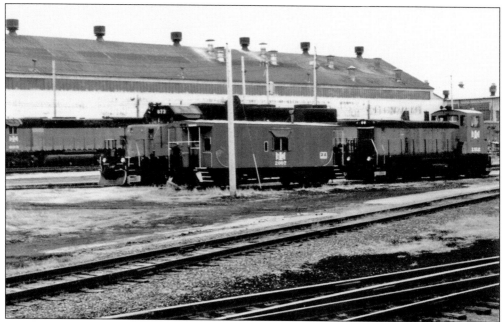

Bessemer and Lake Erie Railroad six-axle, type SD38-2 locomotive No. 873, rated 2,000 horsepower; caboose No. 2007; and switcher type SW1500 locomotive No. 152, rated 1,500 horsepower, are at the Greenville shops on April 10, 2003. The Electro-Motive Division of General Motors Corporation built these locomotives. Major locomotive repairs were done at this facility. (Photograph by Brian C. Sherman.)

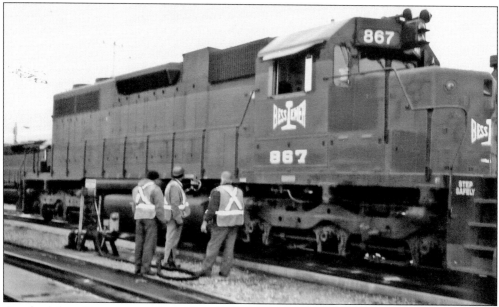

On the left, a Bessemer and Lake Erie Railroad transportation employee (who operates the locomotive) is discussing with two maintenance-of-equipment employees the preparation needed for locomotive No. 867 during 2006. Built by the Electro-Motive Division of General Motors Corporation during 1971, this type SD38AC, six-axle diesel unit was rated 2,000 horsepower. (Photograph by Brian C. Sherman.)

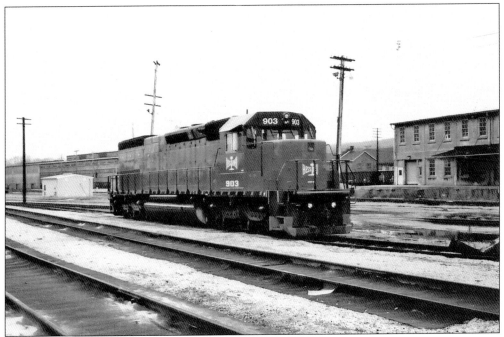

The Greenville yard is the scene for Bessemer and Lake Erie Railroad locomotive No. 903 waiting for service. This six-axle locomotive was built during 1974 by the Electro-Motive Division of General Motors Corporation as Southern Pacific Railroad No. 9351 and was purchased rebuilt as a 3,000-horsepower type SD40T-3 diesel unit during 1999. (Photograph by Brian C. Sherman.)

From left to right, CSX Corporation type ES44AC locomotive No. 720, built by General Electric Company and rated 4,400 horsepower (awaiting the locomotive crew), and Bessemer and Lake Erie Railroad 3,000-horsepower, type SD40T-3 locomotives No. 905 and No. 908, originally built by the Electro-Motive Division of General Motors Corporation, are at the Greenville yard during 2006. (Photograph by Brian C. Sherman.)

Type SD-18 locomotives No. 859 (built in 1960) and No. 858 (built in 1959) are at the Greenville shops for service during 2008. The Electro-Motive Division of General Motors Corporation originally built these locomotives for the Duluth, Missabe and Iron Range Railway, and they were later assigned to the Conneaut harbor. (Photograph by Brian C. Sherman.)

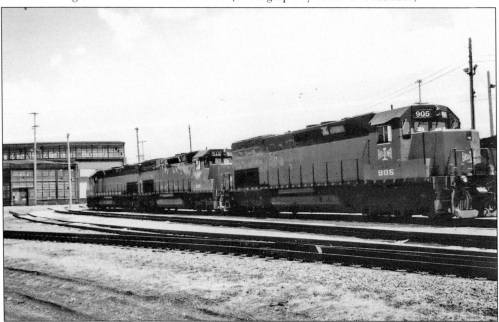

Bessemer and Lake Erie Railroad locomotives No. 905 and No. 910 are among the three type SD40T-3 locomotives at the Greenville yard awaiting the next assignment. These locomotives received in 1999 had a rebuilt main traction alternator, traction motors, cooling fan motors, and dynamic brake fan motors. (Photograph by Brian C. Sherman.)

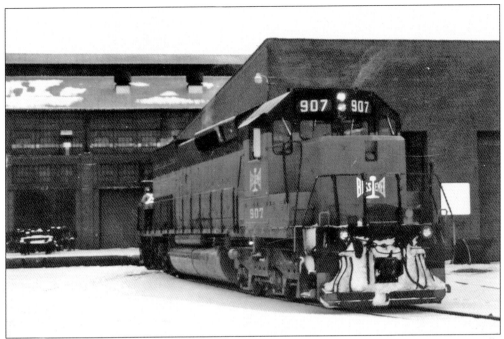

Bessemer and Lake Erie Railroad type SD40T-3 locomotive No. 907 is going into the Greenville shops for repair during the winter of 2008. This six-axle, 3,000-horsepower locomotive was originally built by the Electro-Motive Division of General Motors Corporation in September 1973 and was obtained after being completely rebuilt during 1999. (Photograph by Brian C. Sherman.)

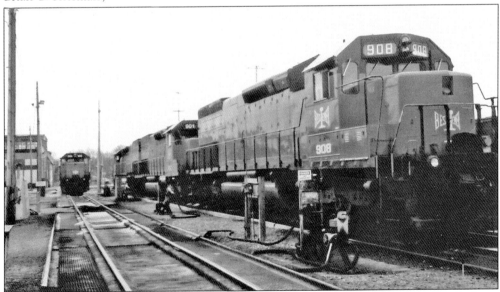

In 2006, Bessemer and Lake Erie Railroad type SD40T-3 locomotives No. 908 (built in March 1973) and No. 901 (built in May 1972) are being serviced at the Greenville shops. These six-axle locomotives were designed as "tunnel motors" to handle operation in long railroad tunnel environments of the western United States and were extensively rebuilt for this railroad during 1999. (Photograph by Brian C. Sherman.)

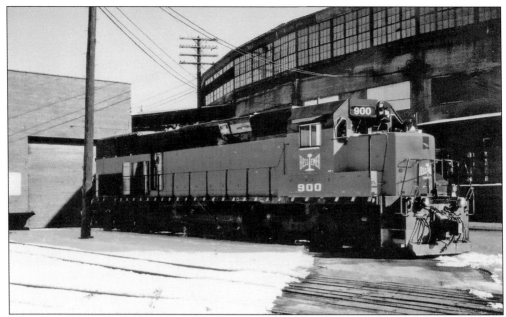

In this January 31, 2005, winter scene, type SD40T-3, six-axle, 3,000-horsepower Bessemer and Lake Erie Railroad diesel locomotive No. 900 is preparing to go into the Greenville shop for service. The Electro-Motive Division of General Motors Corporation originally built this locomotive in February 1973, and it was rebuilt during 1999. (Photograph by Brian C. Sherman.)

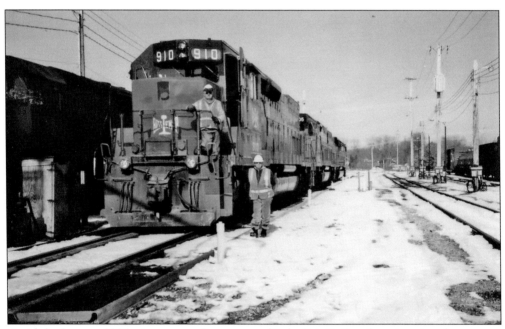

Amid the January 2006 winter snow, Bessemer and Lake Erie Railroad engineering department employees are by locomotive No. 910 at the Greenville shops, getting ready for the next track assignment. This was known as a tunnel motor locomotive, originally built to operate through tunnels in the mountains of the western United States. (Photograph by Brian C. Sherman.)

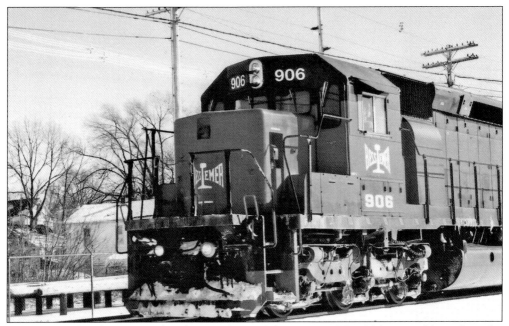

Bessemer and Lake Erie Railroad type SD40T-3 locomotive No. 906 is northbound at the Greenville yard during 2006. This type of locomotive was originally built to handle tunnels and snowsheds in the Sierra Nevada Mountains where there was a need to intake cooler air to reduce the temperature of the locomotive's cooling systems. (Photograph by Brian C. Sherman.)

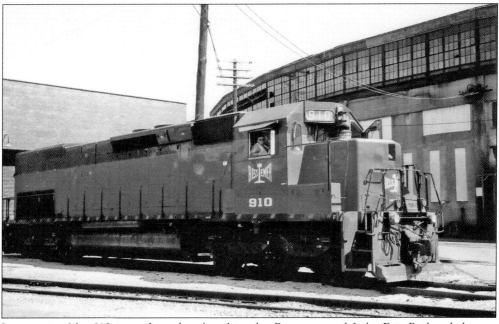

Locomotive No. 910 is ready to be placed in the Bessemer and Lake Erie Railroad shop at Greenville for maintenance during 2008. Through turbocharging (a method of using exhaust gases to compress engine intake air to make the air more dense, allowing more fuel to be burned in each engine cylinder), more horsepower was produced in locomotives numbered 900 to 910. (Photograph by Brian C. Sherman.)

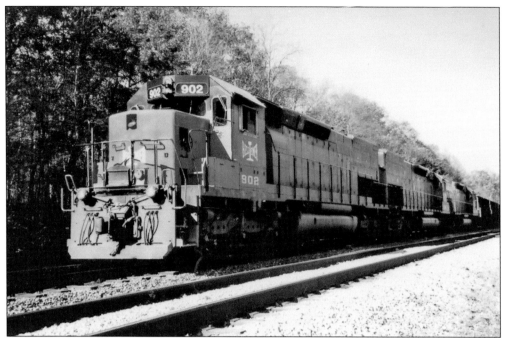

At the south end of the Branchton yard, Bessemer and Lake Erie Railroad type SD40T-3 locomotive No. 902 is waiting for clearance to proceed southbound to North Bessemer. This locomotive was purchased as rebuilt during 1999 with a new computer system that improved tractive effort and controlled other locomotive functions. (Photograph by Brian C. Sherman.)

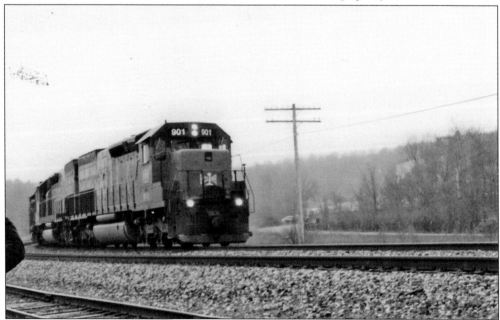

A northbound train headed by Bessemer and Lake Erie Railroad type SD40T-3 locomotive No. 901 is approaching Branchton Road east of the borough of Slippery Rock on May 7, 2005. This was one of 11 locomotives numbered 900 to 910 that were purchased secondhand and extensively rebuilt during 1999. (Photograph by Brian C. Sherman.)

The Calvin yard, about a mile north of the city limits of Butler, is the scene for a southbound train headed by Bessemer and Lake Erie Railroad six-axle, type SD40T-3 locomotive No. 907. The Electro-Motive Division of General Motors Corporation built this locomotive in September 1973, and it was extensively rebuilt during 1999. (Photograph by Brian C. Sherman.)

Bessemer and Lake Erie Railroad type SD40T-3 locomotive No. 900 is handling a train at Zenith Road in Butler during 2006. This locomotive was one of 11 numbered 900 to 910 extensively rebuilt during 1999, including repair to the car body, rebuilt electrical equipment, and new high-voltage cabling, pipe work, radiators, and oil coolers. (Photograph by Brian C. Sherman.)

Discover Thousands of Local History Books
Featuring Millions of Vintage Images

Arcadia Publishing, the leading local history publisher in the United States, is committed to making history accessible and meaningful through publishing books that celebrate and preserve the heritage of America's people and places.

Find more books like this at
www.arcadiapublishing.com

Search for your hometown history, your old stomping grounds, and even your favorite sports team.

Consistent with our mission to preserve history on a local level, this book was printed in South Carolina on American-made paper and manufactured entirely in the United States. Products carrying the accredited Forest Stewardship Council (FSC) label are printed on 100 percent FSC-certified paper.